Art in Context

Leonardo: The Last Supper

Art in Context

Edited by John Fleming and Hugh Honour

Each volume in this series discusses a famous painting or sculpture as both image and idea in its context – whether stylistic, technical, literary, psychological, religious, social or political. In what circumstances was it conceived and created? What did the artist hope to achieve? What means did he employ, subconscious or conscious? Did he succeed? Or how far did he succeed? His preparatory drawings and sketches often allow us some insight into the creative process and other artists' renderings of the same or similar themes help us to understand his problems and ambitions. Technique and his handling of the medium are fascinating to watch close up. And the work's impact on contemporaries and its later influence on other artists can illuminate its meaning for us today.

By focusing on these outstanding paintings and sculptures our understanding of the artist and the world in which he lived is sharpened. But since all great works of art are unique and every one presents individual problems of understanding and appreciation, the authors of these volumes emphasize whichever aspects seem most relevant. And many great masterpieces, too often and too easily accepted and dismissed because they have become familiar, are shown to contain further and deeper layers of meaning for us.

Art in Context

*Leonardo da Vinci was born at Vinci, near Florence, on 15 April 1452 and died on
2 May 1519 at le Clos-Lucé (Cloux), Amboise, in France. He was brought up
by his father who later became a respected notary in Florence. From about 1467 he
was trained as a painter and sculptor under Verrocchio in whose house he lived
until 1476. He became a master of his guild in 1472. He left Florence around 1482
when he was invited to Milan by Lodovico Sforza. He stayed there until 1499,
returning to Florence in 1500 until 1506. He was again in Milan until 1513, then
chiefly in Rome until he went to France in 1517. Painter, sculptor, architect,
musician, mathematician, engineer, scientist and inventor, Leonardo was one of the great
Universal Men produced by the Renaissance. Few paintings by him have survived
but there are many authentic drawings.*

*The Last Supper in the Refectory of S. Maria delle Grazie, Milan, is painted in a kind
of tempera on stone and measures 460 x 880 cm. It was probably commissioned in
1494 and was far advanced by 1497 though not completed until 1498. The surface had
already begun to decay noticeably by 1517 and it is questionable how much of
Leonardo's actual painting survives since it has been restored and repainted almost
continuously over four and a half centuries.*

Readers Union Group

Leonardo: The Last Supper

Ludwig H. Heydenreich

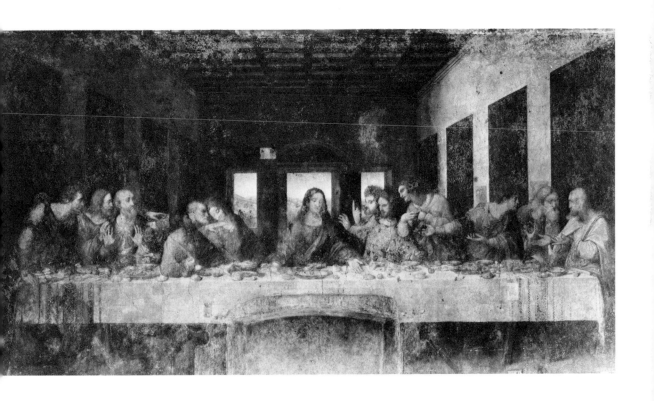

Allen Lane
A Division of Penguin Books Ltd
17 Grosvenor Gardens, London SW1 8BY

ISBN *0 7139 0410 0*

Filmset in Monophoto Ehrhardt by Oliver Burridge Filmsetting Ltd, Crawley, England
Colour plate reproduced and printed by Colour Reproductions Ltd, Billericay, England
Printed and bound by W. & J. Mackay Ltd, Chatham, England
Designed by Gerald Cinamon and Paul McAlinden

This edition issued 1974 by Readers Union by arrangement with Allen Lane

Acknowledgements 9

Historical Table 10, 11

1. Introduction 12

2. Commission and Execution 14

3. Content and Form 25

Appendix 1 : The Gospel Accounts of the Last Supper 73

Appendix 2 : Goethe and Leonardo's Last Supper 85

Appendix 3 : Condition and Restoration 91

Appendix 4 : Copies of Leonardo's Last Supper 99

Notes 107

List of Illustrations 115

Bibliography 119

Index 122

Reference colour plate at end of book

Acknowledgements

I am sincerely grateful to Mrs Elisabeth Beatson at Princeton who most carefully, and with great understanding and intuition, revised the English translation of this book. To Dr Franco Russoli, director of the Galleria di Brera, and to Padre Angelo M. Caccin O.P. of S. Maria delle Grazie I am greatly indebted for photographs and for other help. I should also like to thank the editors of this series, John Fleming and Hugh Honour, for many helpful suggestions regarding the presentation of the material, especially in the preparation of the appendices.

Finally, I should like to remember here, with gratitude, the debt we all owe to the late Gino Chierici who was Superintendent of Monuments in Lombardy during the last war. The survival of *The Last Supper* is due to his care and foresight. Had it not been for the steel armature filled with sand-bags which he had erected to protect it, *The Last Supper* would certainly have been destroyed by the bombs which fell on 13 August 1943.

Historical Table

1490	Treaty between England and Lodovico Sforza of Milan.
1491	
1492	Lorenzo de' Medici dies.
	Pope Alexander VI (Borgia) elected.
	Columbus sails from Palos.
1494	Charles VIII invades Italy, expels Medici from Florence.
	Savanarola becomes chief figure in Florentine republic.
	Spain and Portugal divide the New World between them.
1496	
1497	Vasco da Gama rounds the Cape.
1498	Savanarola burnt in Florence;
	Machiavelli becomes Secretary of State.
1499	Lodovico Sforza expelled from Milan by French army under Louis XII.
1500	Alexander VI proclaims crusade against the Turks; Cesare Borgia's conquests in central Italy.
1501	
1502	Leonardo becomes Cesare Borgia's military engineer.
1503	Death of Alexander VI and collapse of Cesare Borgia's power.
1504	
1505	Luther enters Augustinian Friary at Erfurt.

<table>
<tbody>
<tr><td></td><td></td><td>1490</td></tr>
</tbody>
</table>

		1490
Leonardo begins main phase of work on the Sforza monument.		1491
Bramante begins choir of S. Maria delle Grazie. Piero della Francesca dies.	Franchino Gafurio: *Theorica musice*.	1492
Leonardo commissioned to paint *The Last Supper*. Hans Memling dies.	Sebastian Brandt: *Narrenschiff* Pico della Mirandola, Poliziano and Boiardo die.	1494
Michelangelo in Rome. Perugino: *Crucifixion*.	Pico della Mirandola: *Disputationes* published posthumously.	1496
		1497
Leonardo: *The Last Supper*. Dürer: *Apocalypse*.	Luca Pacioli: *De divina proportione*. Philippe de Commines finishes his memoirs.	1498
Leonardo leaves Milan. Signorelli begins frescoes in Orvieto.	F. Colonna: *Hypnerotomachia Poliphili*. Ficino dies.	1499
Leonardo returns to Florence; begins *The Virgin and St Anne*. Michelangelo: *Pietà*.	Erasmus: *Adagia*.	1500
Michelangelo returns to Florence, begins the *David*.		1501
Leonardo probably begins the *Mona Lisa*.		1502
	Ariosto begins *Orlando Furioso*.	1503
Leonardo begins the *Battle of Anghiari*; Michelangelo: *Battle of Cascina*. Raphael: *Sposalizio*.	P. Gauricus: *De sculptura*. F. M. Grupaldi: *De partibus sedium libri due*. Sannazaro: *Arcadia*.	1504
Dürer returns to Italy.	Bembo: *Gli Asolani*.	1505

1. Introduction

Very few works of art, even among the greatest and most widely appreciated masterpieces, have entered into the general consciousness and become, in a certain sense, the spiritual possession of the whole world. Leonardo da Vinci's *Last Supper* is among these exalted few – indeed it stands supreme among them. [See colour plate at end of book.]

This great painting has always been famous. It began to acquire its unique reputation immediately after it was finished when Luca Pacioli eulogized it in the dedication of his *De divina proportione* to Lodovico il Moro, dated 8 February 1498. Its renown soon spread throughout Europe. Nor has its prestige ever diminished, despite all the subsequent fluctuations in taste and in artistic styles and despite the rapid physical deterioration of the painting itself, which began only too soon. In the great disputes over the basic principles and purpose of art which raged for three centuries, especially in Italy, France and England, this painting's status as a perfect creation was never questioned, let alone doubted.

The perfection of the work lies not only in the formal or purely artistic merits of the composition but also in Leonardo's expressive mastery, in his deeply human and profoundly felt exposition of the subject. He created an ideal pictorial representation of the most important event in the Christian doctrine of salvation – the institution of the Eucharist – and his representation has maintained its absolute validity over and above all later doctrinal and other divisions of the Church. Countless copies and reproductions of it have been diffused in schools and homes and places of worship of all denominations (both Catholic and Protestant) in all countries. It would be hard to name another representation of any part of the Christian story which

has achieved such a perennial and unanimous – completely oecu-
menical – acceptance and authority. Nor does any other painting of
a Christian subject dominate our imagination with the same power:
whenever our thoughts turn to the Last Supper we seem to see
Leonardo's composition before us.

 Let us now turn to the work itself and the history of its genesis as
image and idea.

2. Commission and Execution

The Dominicans of S. Maria delle Grazie in Milan enjoyed from the start the special favour of the ducal court. In 1458 their mother house in Pavia had been requested to found an offshoot in Milan. Count Gaspare Vimercato gave the new arrivals the piece of land on which, from 1464 to 1482, the imposing friary and its church were erected.[1] The protection in high quarters continued: the church and friary had hardly been in existence for ten years when they once again found a great and ambitious patron. Lodovico Sforza [1], proudly conscious of his swiftly won political power and anxious to give visible expression to his position also in impressive buildings, had chosen S. Maria delle Grazie as court church and burial place for his family. He decreed that the building should receive a more splendid form in accordance with this lofty function. On 29 March 1492 Archbishop Guido d'Antonio solemnly laid the foundation stone of the new choir [2], which was designed by Bramante as a mighty cube crowned by a dome.[2]

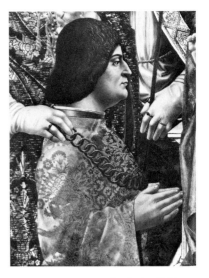

1. Lodovico il Moro, detailed from the *Pala Sforzesca*, c. 1495. Anonymous

2 (*opposite*). Choir of S. Maria delle Grazie, Milan, 1492. Bramante

Lodovico also devoted his special attention to the monastery itself and provided it with rich endowments. This munificence included the extension and appropriate decoration of the interior. He put to work on this great project the two best artists of his court: Donato Bramante was entrusted with the direction of the architectural work and Leonardo da Vinci was commissioned to execute a painting of the Last Supper in the refectory, which was likewise enlarged [3, 4]. It was under these circumstances that one of the most perfect creations of Western art came into being.

Contemporary sources are scanty, nevertheless they provide us with one or two reliable indications about the progress of the work. Probably commissioned in 1494,[3] it was far advanced in 1497 and

completed in 1498.[4] We also possess a very lively description by an eye-witness who watched *The Last Supper* being painted. The famous novella writer Matteo Bandello, as a young monk and the guest of his uncle, the Abbot of S. Maria delle Grazie, saw Leonardo at work in 1497 and incorporated his memories of this experience in one of his stories.

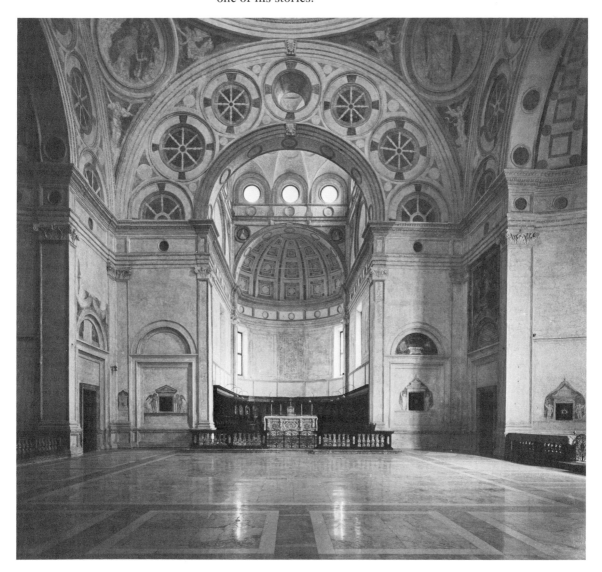

'Many a time', he says, 'I have seen Leonardo go early in the morning to work on the platform before *The Last Supper*; and there he would stay from sunrise till darkness, never laying down the brush, but continuing to paint without eating or drinking. Then three or four days would pass without his touching the work, yet each day he would spend several hours examining it and criticising the figures to himself. I have also seen him, when the fancy took him, leave the Corte Vecchia when he was at work on the stupendous horse of clay, and go straight to the Grazie. There, climbing on the platform, he would take a brush and give a few touches to one of the figures: and then suddenly he would leave and go elsewhere.'[5]

However, the careful consideration which – as is clear from this evidence and from many other credible anecdotes handed down from later periods[6] – Leonardo devoted to his work also determined his choice of medium, a choice which, as time was to show, turned out to be an unfortunate one. His mode of working, marked as it was by intense intellectual concentration but a hesitant manner of execution, did not suit the commonly used fresco technique, which requires a swift, assured approach and precludes any change in the course of the work. In order to be able to continue his usual manner of working Leonardo devised his own technique for mural painting, a sort of tempera on stone. The wall must first have been coated with a strong ground of some material which would not only absorb the tempera emulsion but also protect it against moisture. This ground, which he compounded out of gesso, pitch and mastic, has not proved durable. The pigment soon began to break loose from the ground and a process of progressive decay set in which could be described as 'the tragedy of *The Last Supper*'. As early as 1517 Antonio de Beatis referred to it as an excellent picture, but one that was beginning to decay, 'though whether because of the dampness of the wall or some other mischance I cannot say'.[7] The painter Giovanni Battista Armenini, who saw the work towards the middle of the century, calls it 'half ruined'[8] (mezzo guasto) and Vasari, who

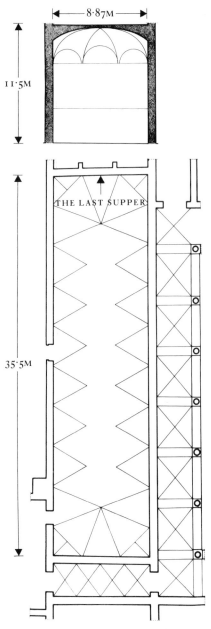

3. The refectory, S. Maria delle Grazie, section and plan

4. Interior, the refectory

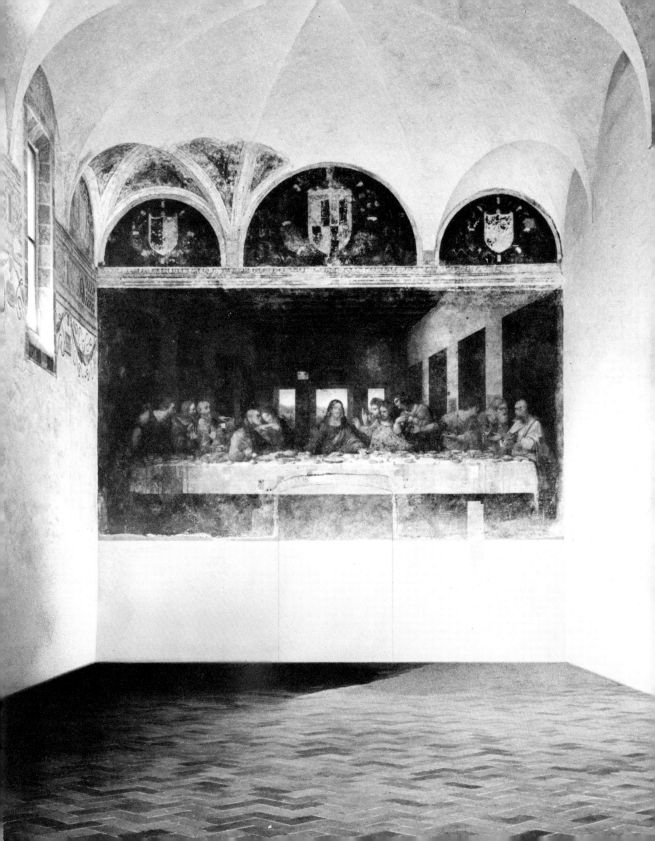

visited the monastery in May 1556, speaks of it as 'so badly affected that nothing is visible but a mass of blots' (macchia abbagliata).[9]

The process of decay proceeded inexorably through the centuries. Frequent and careless restorations made the condition of the painting even more deplorable.[10] The year 1652 saw the construction of a doorway which ruthlessly eliminated the lower central area of the painting. But no tampering with the surface-layer could succeed in destroying the magic power of the original picture; it still continued to exert its overwhelming effect on the spectator. One of the finest testimonies we possess is the verdict of Rubens, which has come down to us through Roger de Piles:

'He [Leonardo] allowed nothing to escape him that could assist in the expression of the subject he had chosen. By the fire of his imagination and the strength of his judgement he exalted divine things through human things and was able to lend men every degree of worth up to the heroic.

'The finest example he has left us is the Last Supper which he painted in Milan. He has depicted each of the Apostles in the spot appropriate to him and the Lord in the place of honour in their midst, with no one constricting him or too near to him. His attitude is serious, and his arms lie free and at rest, to lend further emphasis to the impression of greatness. The Apostles, on the other hand, move this way and that in the violence of their unrest, which yet shows no trace of vulgarity or of offence against good order. In a word, as a result of deep thought he has attained such a degree of perfection that it seems to me impossible to speak in adequate terms of his work, let alone imitate it.'[11]

A century later the painting was still a main objective of all visitors to northern Italy. By then the repeated attempts at restoration had almost totally effaced the original – though the restorers appear to have gone on undaunted with their retouchings and repaintings. The Irish painter James Barry gives a vivid description of their recent handiwork in 1770. 'This glorious work of Leonardo is now no more', he declared in one of his Academy lectures.

'I saw the last of it at Milan; for in passing through that city, on my return home [in 1770] I saw a scaffold erected in the Refettorio, and one half of the picture painted over by one Pietro Mazzi; no one was at work, it being Sunday, but there were two men on the scaffold, one of whom was speaking to the other with much earnestness about that part of the picture which had been re-painted. I was much agitated, and having no idea of his being an artist, much less the identical person who was destroying so beautiful and venerable a ruin, I objected with some warmth to the shocking ignorant manner in which this was carried on, pointing out at the same time the immense difference between the part that was untouched and what had been re-painted. He answered, that the new work was but a dead colour, and that the painter meant to go over it all again. Worse and worse, said I: if he has thus lost his way when he was immediately going over the lines and features of Leonardo's figures, what will become of him when they are all thus blotted out, and when, without any guide in repassing over the work, he shall be utterly abandoned to his own ignorance. On my remonstrating afterwards with some of the friars, and entreating them to take down the scaffold and save the half of the picture which was yet remaining, they told me that the convent had no authority in this matter, and that it was by the order of the Count de Firmian, the Imperial Secretary of State. Thus perished one of the most justly celebrated monuments of modern art, particularly for that part of design which regards the skilful delineation of the various sentiments of the soul, in all the diversities of character, expression of countenance, and of action.'[12]

Barry's protests appear to have been more successful than he realized. For it may possibly have been his intervention that persuaded the new Prior of the monastery, Paolo Gallieri, to prevent Mazza from continuing his unfortunate work by the simple expedient of removing the scaffolding (see Appendix 3).

Towards the end of the eighteenth century, continuing admiration of the great work gave rise to the feeling that something should be done to save it. Historical interest in the great masters of the

Renaissance stimulated by classicism encouraged in the case of Leonardo various attempts to preserve his most important creation, *The Last Supper*, for posterity. In 1789, on behalf of Louis XVI of France, André Dutertre began to study *The Last Supper*. In 1794 he entered his 'reconstruction' in the form of a small-scale gouache, the fruit of many years' work for the 'Prix de Dessin' of the – by then Republican (!) – Louvre and was awarded the prize. This work [5], in my opinion the best existing copy of Leonardo's picture, only became known again in 1958, when it came into the possession of the Ashmolean Museum at Oxford.[13] The same impulse was responsible for the numerous other efforts made at that time to produce a faithful copy of *The Last Supper*, in particular Giuseppe Bossi's great undertaking, which prompted Goethe's essay, one of the finest of all literary tributes to Leonardo's painting (see Appendix 2). Other moves in the same direction were the studies by Andrea Appiani and Teodoro Matteini, and the anonymous Weimar series of Apostles' heads. These efforts culminated in the copper engravings by Raphael Morghen [6] and Giacomo Frey (1803).[14]

5. Copy of *The Last Supper*, 1789–94. André Dutertre

6. Engraving after *The Last Supper*, 1800. R. Morghen

Simultaneously with these historical studies and attempts at a faithful imaginary reconstruction of Leonardo's picture, new restoration campaigns were begun to preserve the work itself. It had passed through a dangerous period following the entry of French troops into Milan in 1796. According to the story of an eye-witness, Padre Giuseppe Antonio Porro, Napoleon himself intervened to protect it. After visiting the by then suppressed monastery and seeing *The Last Supper*, he scribbled an order on his knee before mounting his horse – 'che quel luogo fosse rispetato, né vi si desse alloggio militare o vi facesse altro danno'[15] (that this place be respected and that it neither be used as a barracks nor be misused in any other way). But his orders were not obeyed. The monastery became successively quarters for officers, troops and prisoners: the refectory was used as a magazine, a stable and a hay-store, and *The Last Supper* received rough treatment. Only after the establishment of the Italian Republic in 1802 were efforts made to take proper care of the room and paint-

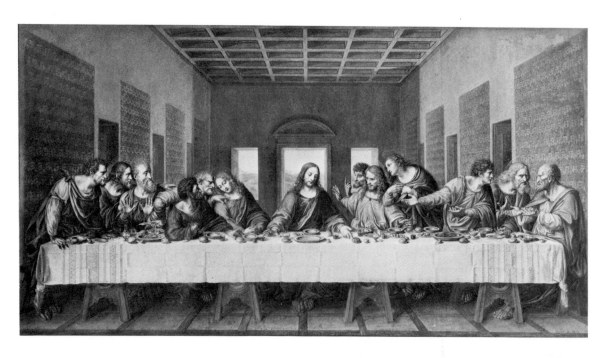

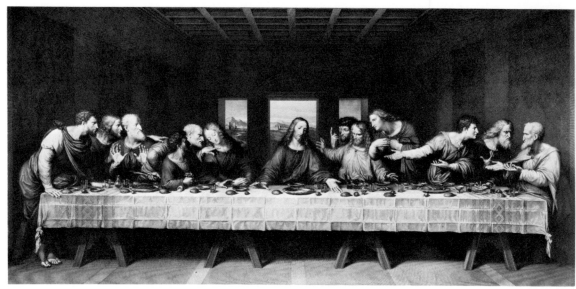

ing. The painter Andrea Appiani, then Commissioner of Fine Arts for Lombardy, was charged with the supervision of the work. But at first repairs were limited to the structure of the refectory itself. Later, in 1807-9, Giuseppe Bossi executed his full-scale copy of the painting (destroyed in the Second World War). The restoration of *The Last Supper* proceeded by fits and starts from 1819 to 1823 and then again in 1854-5 under Stefano Barezzi. These restorations went on through the century and form a chapter of their own in the history of restoration techniques (see Appendix 3). Efforts made at the beginning of the twentieth century to rescue the painting from further decay also had little success. It was these attempts at conservation, undertaken as they were with little confidence, that inspired Gabriele d'Annunzio's ode 'On the Death of a Masterpiece'.[16]

In 1924 a new restoration was carried out, which once again consisted mainly in anchoring the loosening layer of colour. Nothing could be done about the basic trouble – the tendency to humidity in the supporting wall. Because of the media used by Leonardo it was not possible to detach the painting and a slow decay seemed inevitable.

When, one August day in 1943, a bomb fell almost completely shattering the great cloister of the church of S. Maria delle Grazie and the surrounding buildings, it was thought for a moment that Leonardo's *Last Supper* had perished with the refectory [7]. But, as though by a miracle, it had survived. The iron framework of the protective shield set up before the painting had acted as a support for the wall, preventing it from collapsing and had thus preserved the picture unscathed. Exemplary care for the preservation of historical monuments had thus saved the work of art itself and soon also restored the refectory.[17] Following the reconstruction of the room it became possible to apply the latest methods of conservation both to the painting and to the wall. Careful cleaning of the surface laid bare large sections of original paint, so that as compared with the pre-war condition the character of the work as a whole has been

23

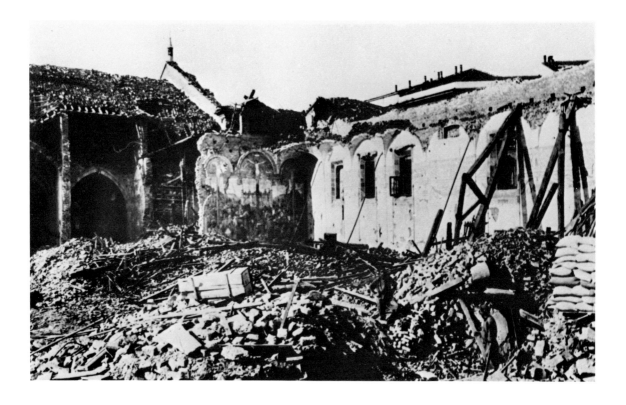

7. The bombed refectory, 1943. *The Last Supper* is behind the sand-bags on the right

tremendously improved. It might have been expected that this most recent restoration, carried out under the direction of Mauro Pellicioli, completed in 1954 and involving the minute work of anchoring individually thousands upon thousands of particles of paint by means of a solution of shellac, would put a halt to further decay.[18] However, these hopes have not been realized; on the contrary, serious anxiety continues to prevail. Variations in temperature in the refectory and the inherent porosity of the wall, which still continues to absorb moisture, subject the painting to stresses which in the long run it cannot tolerate. The need to eliminate this dangerous situation confronts modern scientific techniques of restoration, which have recently made such amazing progress, with one of their greatest challenges.

3. Content and Form

Although *The Last Supper*, after all the hazards to which it has been exposed, now retains only a shadow of its original perfection, it nevertheless casts an overwhelming spell on all who see it. Monumental in size – it measures twenty-eight and a half feet by fifteen – it occupies the whole north end of the refectory. The setting in the picture is a continuation in perspective of the real room, so that Christ's table seems to be in the refectory itself; thus the Lord appears to share, as their 'spiritual Prior', the monks' own repast [8].

8. *The Last Supper*, Leonardo

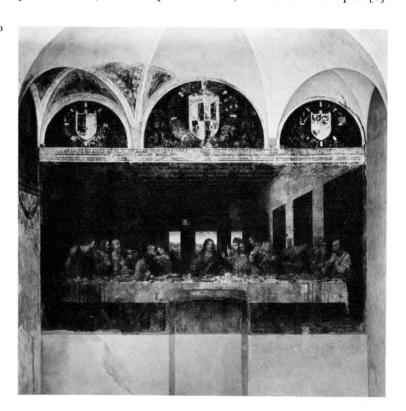

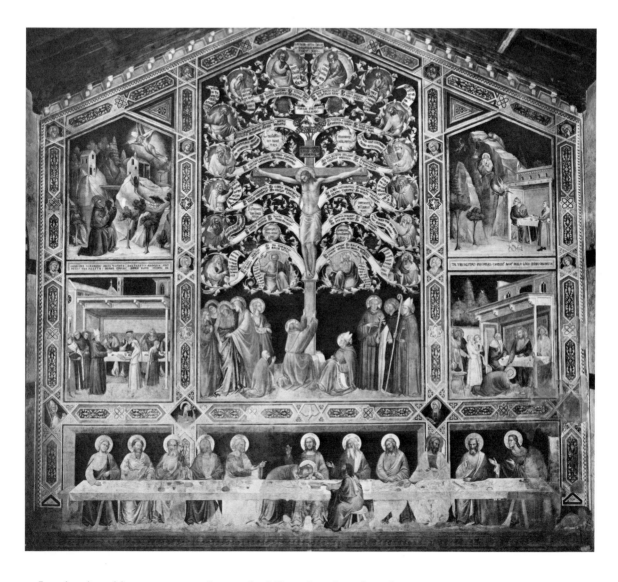

9. *The Last Supper and Other Scenes*, *c.* 1350. Taddeo Gaddi

In adopting this arrangement Leonardo followed and perfected a tradition developed in the course of the fourteenth and fifteenth centuries in connection with the rise of the great representative monastic buildings. Until then the Last Supper had usually appeared in sacred wall paintings as part of the Passion cycle, but in this period it emerges as an isolated scene and acquires a par-

ticular significance as a subject for refectories.[19] When he began his task in Milan, Leonardo was doubtless perfectly familiar with the theme through its frequent use on painted panels and predellas

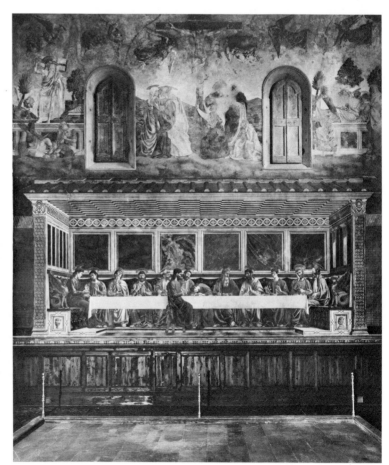

10. Fragment of *The Last Supper*, *c.* 1365. Orcagna

11 (above right). *The Last Supper Crucifixion, Entombment and Resurrection, c.* 1450. Castagno

and in carved altars, and he must have had in mind the several important examples of the monumental treatments of the subject then to be seen in Florence. The scene had been painted in the monastery of S. Croce by Taddeo Gaddi about 1350 [9], for S. Spirito by Orcagna about 1365 [10], by Andrea del Castagno about 1450 in S. Apollonia [11] and, in 1480, by Domenico Ghirlandaio in the

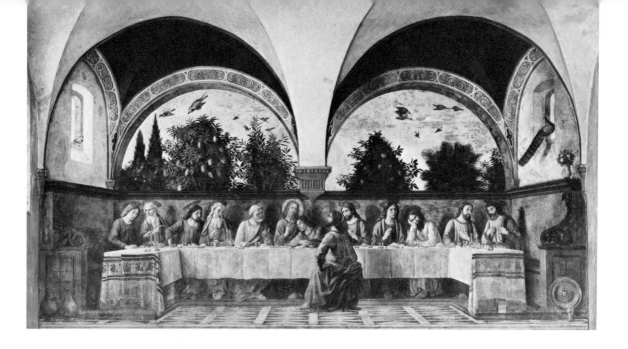

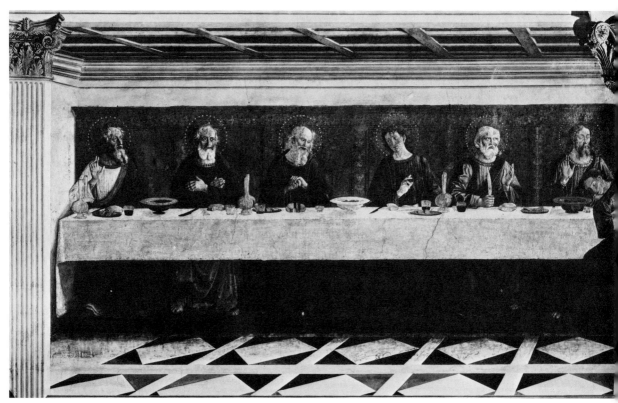

convent of Ognissanti [12]. The version in the convent of S. Marco was painted in the 1480s when Leonardo had already left Florence for Milan. But it is possible that Leonardo had also seen the beautiful early version of the subject [13] produced in the seventies by Domenico Ghirlandaio and his brother Davide for the refectory of the Badia (Abbey) of Passignano.[20] Yet if one compares Leonardo's preparatory studies and his finished painting with these works, only the very slightest traces of a possible relationship can be detected. Leonardo may have recalled some types of the Apostles; for example, the gesture of Simon with outstretched hands at the right end of the table is prefigured in Gaddi's painting; Philip's hands are similarly brought together in front of his chest in Ghirlandaio's

12 (*opposite*). *The Last Supper*, 1480. Domenico Ghirlandaio

13. *The Last Supper*, *c.* 1470–79. Domenico and Davide Ghirlandaio

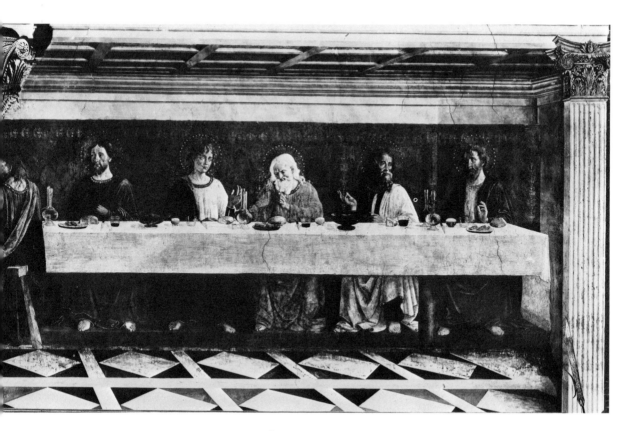

fresco in Ognissanti; and Leonardo's Peter in the Albertina draw-
ing [14] (almost identical with the Windsor study no. 12542) re-
sembles the left-hand outer Apostle at Passignano [15]. Finally, the
gesture of Andrew, with raised hands as if to avert something, is
twice employed by Castagno's Apostles [16]. But these correspon-

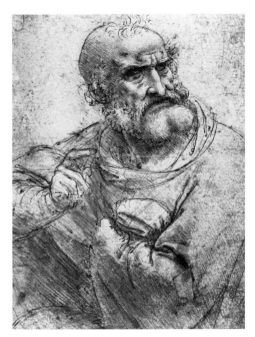 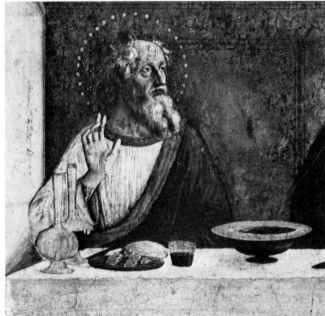

dences – in so far as they have any relevance – only serve to show
all the more clearly what life and spirituality these various motifs
acquire in Leonardo's work.

14. Study for St Peter,
c. 1495. Leonardo

15. Detail of 13

 The use of perspective which Leonardo would have observed
already in Castagno's scene, and even more so in Ghirlandaio's,
undergoes a similar transformation. With bold logicality he employs
and develops it to create an apparent extension of the real room and
thus endows the mere illusionistic effect with symbolic content.
One may go further, for Leonardo seems to have determined the
outer limits of his pictorial space according to mathematical pro-

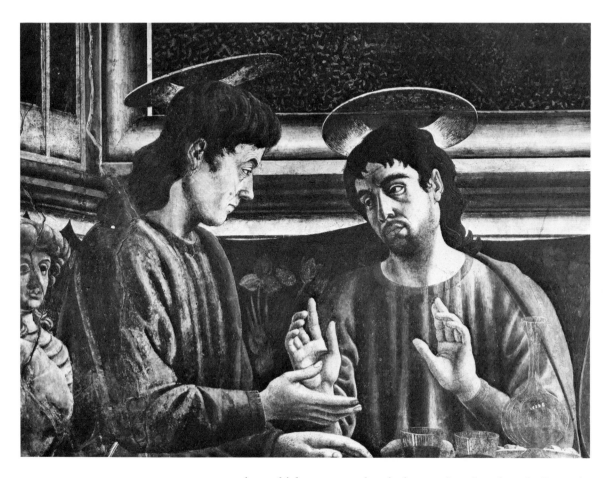

16. Detail of 11

portions which correspond to the harmonic ratios of music. Recently a very searching and stimulating analysis of the space construction of *The Last Supper* [21] has suggested that Leonardo observed the ratio 12:6:4:3 or 1:$\frac{1}{2}$:$\frac{1}{3}$:$\frac{1}{4}$. Thus, it appears that he used numerical proportions which are identical with the Pythagorean intervals in the sense of a *musica mundana* as they are treated by Leonardo's musician friend, Franchino Gafurio, in his *Theorica musice* printed in 1492 – and as they were to appear in a woodcut in his slightly later *Angelicum* [17] printed in 1508, and, nearly twenty years later, in the well-known Pythagorean tablet in Raphael's *School of Athens*.

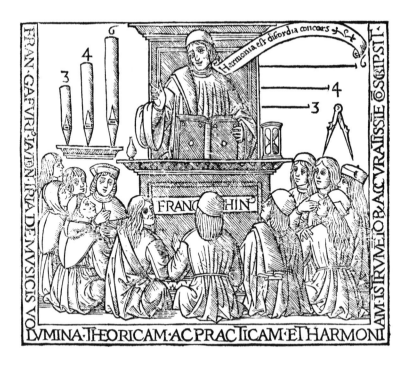

17. Woodcut from Franchino Gafurio, *Angelicum*, 1508

18 (*opposite*). *Agape*, wall painting, late second century. Rome, catacombs

19 (*below right*). *The Last Supper*, sixth century Ms. Rossano

Since Leonardo painted no other comparable interior scene the pictorial space of *The Last Supper* would be a unique case, by which he endowed *prospettiva* – that almost obsessional preoccupation of contemporary art-theorists – with an altogether new and wider dimension: that of the *harmonia perfecta maxima*.

In its content Leonardo's painting shares only its theme with earlier pictures known to him; in his conception and pictorial treatment of the subject he treads a completely new path. In order to gauge the full significance of the new interpretation given by Leonardo to the episode described in the Gospel it will be useful to glance back at the historical development of the iconography of the Last Supper.

From the start, representations of the Last Supper – the earliest versions of the subject are inspired by scenes showing the *agape* or 'love feast' in Early Christian catacomb paintings [18] and begin to appear round the end of the fifth and beginning of the sixth century

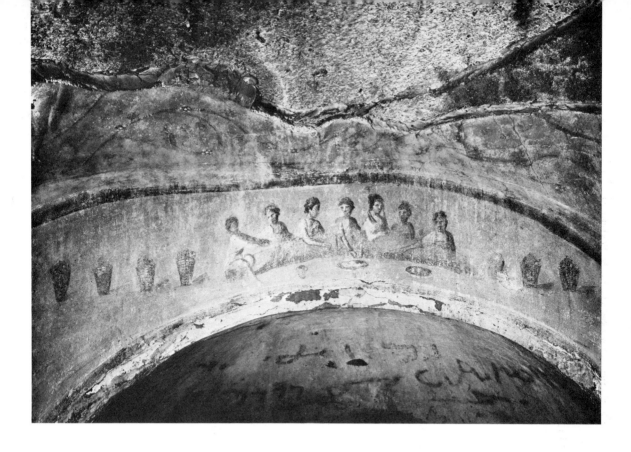

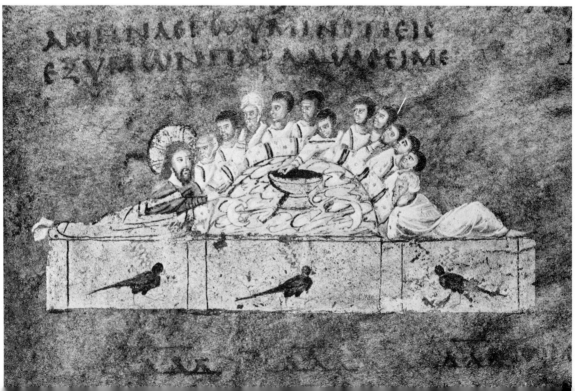

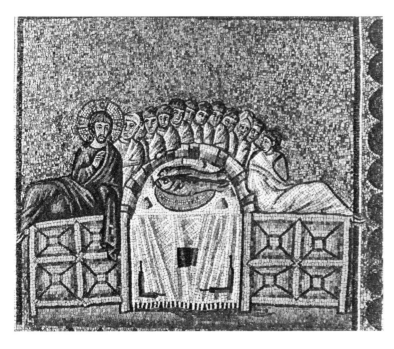

20. *The Last Supper*,
early sixth-century mosaic.
Ravenna

[19, 20] – clearly show the desire to illustrate simultaneously the
two main ideas handed down in the Gospel texts: a reference to the
Passion in the announcement of the betrayal, and the inauguration
of the sacrifice of the New Covenant.[22] Where the Last Supper
forms part of a Passion cycle, two particular iconographic motifs
emerge and are stressed. On the one hand the identification of the
traitor Judas is established by specific gestures described in the
Gospels. Christ gives Judas a piece of bread: 'Jesus answered, He
it is, to whom I shall give a sop, when I have dipped it. And when
he had dipped the sop, he gave it to Judas Iscariot, the son of Simon'
(John xiii, 26). Judas puts his hand in the dish: 'And he answered
and said, He that dippeth his hand with me in the dish, the same
shall betray me' (Matthew xxvi, 23); or rests it on the table: 'But,
behold, the hand of him that betrayeth me is with me on the table'
(Luke xxii, 21). Sometimes the evil spirit is shown entering into
Judas in the form of a bird or monster [21, 22, 23]: 'And after the
sop, Satan entered into him. Then said Jesus unto him: That thou

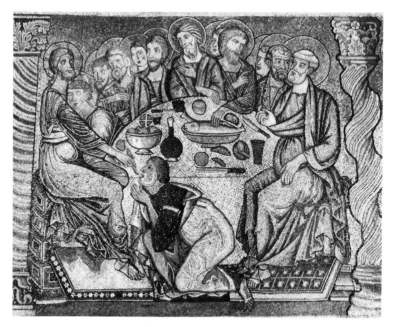

21. *The Last Supper*,
c. 1250–1300 Mosaic.
Florence, Baptistery

22. *The Last Supper*, sixth-century
Byzantine Ms. Milan,
Biblioteca Ambrosiana

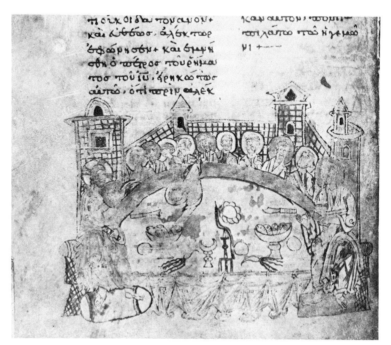

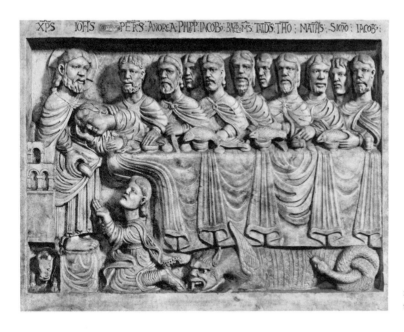

23. *The Last Supper*,
twelfth century, Volterra

24. *The Last Supper*,
c. 1303–13. Giotto

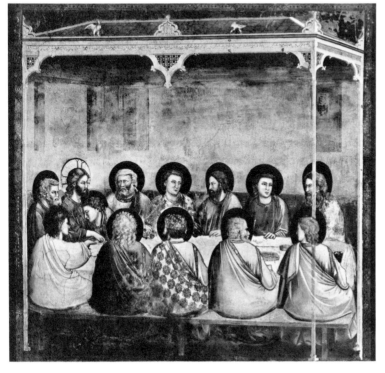

doest, do quickly' (John xiii, 27). In contrast – as a sort of counter-motif to this indication of the betrayal – we find the tender group consisting of John reclining his head against the breast of the Lord: 'Now there was leaning on Jesus' bosom one of his Disciples, whom Jesus loved' (John xiii, 23). This gives the composition a centre of tension both in form and content.

It was this pictorial tradition, familiar to Leonardo from his predecessors in Florence, that was also his point of departure as he took up his task. It is significant that he should have ignored another equally widespread and long-established iconographical composition. I refer here to the arrangement of the disciples round a circular or square table, as developed by Giotto from medieval models [24] and also used with variations by Duccio in the Maestà and later by Sassetta in his picture of the Last Supper [25]. Leonardo could even have seen a derivative of this type outside the gates of Milan in the

25. The Last Supper,
1423-6. Sassetta

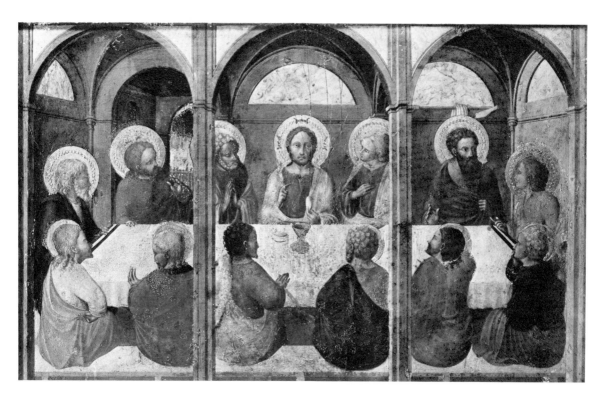

38

Abbey of Viboldone [26].[23] The necessity in this kind of composition of depicting some of the disciples somewhat thanklessly from behind must have been in direct opposition to Leonardo's desire for an expressive and well differentiated characterization of each of the Apostles; and in general it must have seemed to him that it would provide an inadequate opportunity for exploiting the dramatic ele-

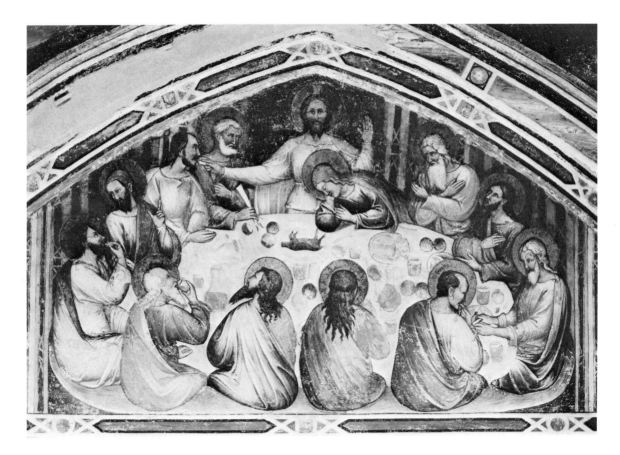

ment. Leonardo also disregarded the lyrical conception to be found in Fra Angelico's paintings of this subject: the calm scene of the 'Apostles' Communion' on the wall of one of the cells in the monastery of San Marco, Florence, and the small, tenderly painted panel in the Passion cycle on a sacristy cupboard [27] executed for

26. *The Last Supper*, late fourteenth century, Viboldone

27 (*opposite*). *The Last Supper*, *c*. 1448–61. Fra Angelico

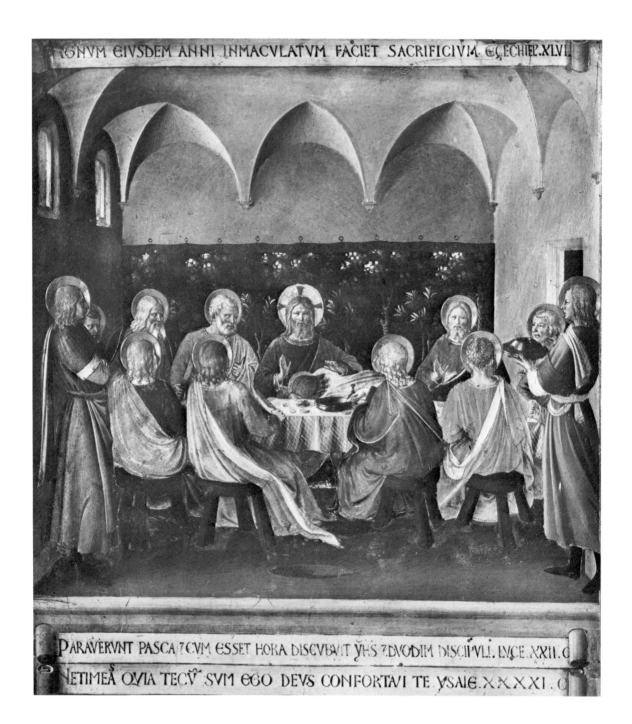

RGNVM EIVSDEM ANNI INMACVLATVM FACIET SACRIFICIVM ECECHIEL·XLVI

PARAVERVNT PASCA 7CVM ESSET HORA DISCVBVIT YHS 7DVODIM DISCIPVLI· LVCE·XXII· C

NETIMEA QVIA TECV SVM EGO DEVS CONFORTAVI TE YSAIE·XXXXI· C

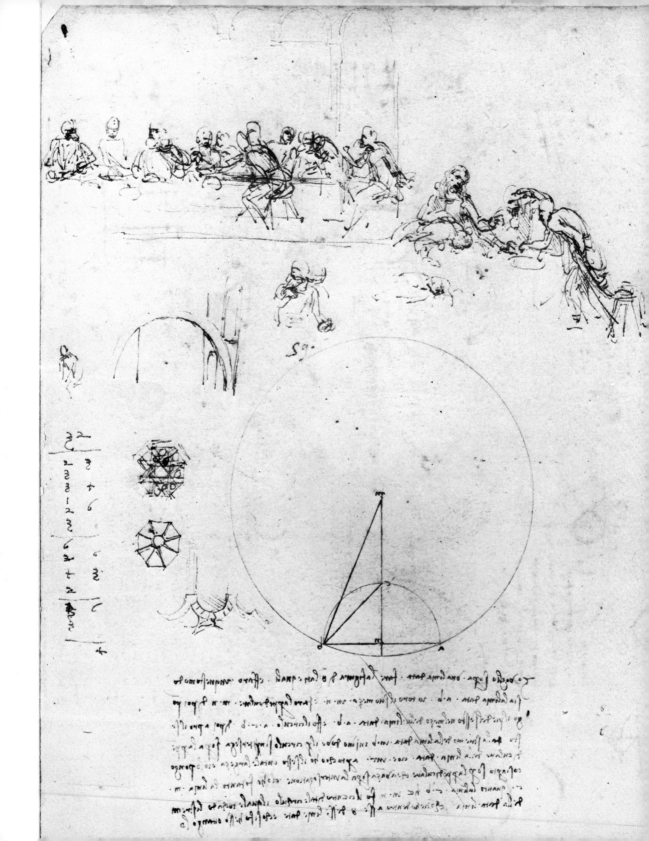

the church of SS. Annunziata, Florence (now in the Museo di San Marco, Florence).[24]

Leonardo's first preliminary studies for the composition, namely the drawing at Windsor (12542 r) [28] and the sheet in Venice [29]

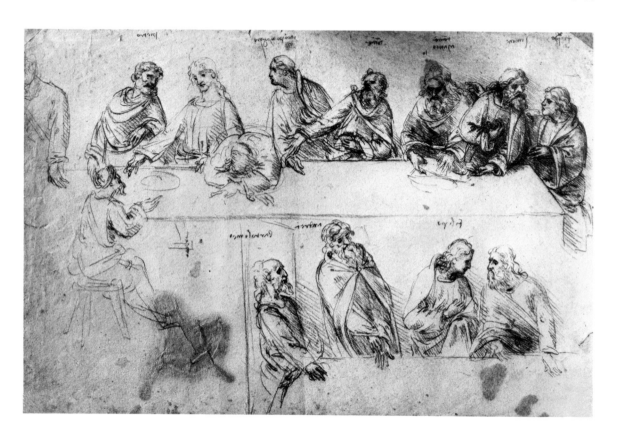

28 (*opposite*). Study for *The Last Supper*, *c.* 1495–7. Leonardo

29 (*above*). Study for *The Last Supper*, *c.* 1495–7. After Leonardo

(the authenticity of which is disputed, but it was unquestionably produced in his studio) testify that his conception of the theme was completely dominated by the idea of bringing out the announcement of the betrayal as the dramatic central motif. In the Windsor sketch we recognize on the right the traditional central group: John, his head almost touching the table and leaning against the breast of the Lord, and Christ about to dip his hand in the dish together with

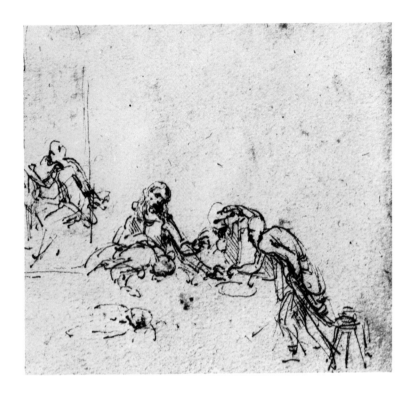

30 and 31. Details of 28

Judas, who is rising from his seat [30]. In the upper left sketch the group at the table is enlarged [31]. We can count eleven figures, each one of whom repays study, especially as these Apostles largely correspond to the types as planned by Leonardo and described in one of his note-books:[25]

'One who was drinking has left his glass in its position and turned his head towards the speaker. Another twists the fingers of his hands together and turns with a frown (con rigide ciglia) to his companion. Another with hands spread open showing the palms, shrugs his shoulders up to his ears and makes a grimace of astonishment (fa la bocca della maraviglia). Another speaks into his neighbour's ear and the listener turns to him to lend an ear, while he holds a knife in one hand and in the other the loaf half cut through by the knife; and in turning round another, who holds a knife, upsets with his hand a glass on the table.'

A BC D E F G H I J K

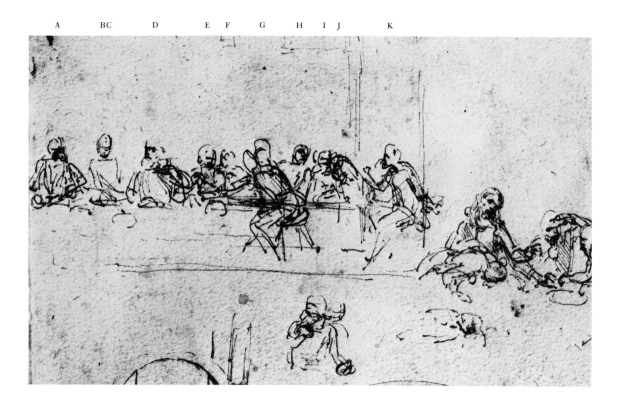

On the Windsor drawing the figures from left to right comprise: (A) a bearded man with head turned to the right, his right hand raised with outstretched forefinger and in his left hand a knife (Peter? This figure is very similar to the drawing of St Peter in Vienna [14]); (B/C) the group consisting of Christ and John, only faintly indicated but corresponding perfectly to the detail sketch alongside; (D) a bearded figure turning to the left with a cup in his raised hand; (E/F) a group of two: the man sitting behind bends over to the one in front who rests his arms with clasped hands on the table, a gesture which Leonardo might have known from Castagno's picture; (G) Judas, on the near side of the table stretching his arm out towards the dish; (H/I/J) a group of three, one of whom leaning back, turns his head to his bearded neighbour, into whose ear the third whispers; (K) a man sitting at the end of the table, raises a piece of bread or a cup to his mouth.

It is only in making a detailed examination of this drawing – the one belonging to the Venetian Academy [29] is a variation on the same theme[26] – that we are able to appreciate the radical alteration which distinguishes Leonardo's final composition from all earlier pictures of the Last Supper. This alteration consists in the attempt to arrange the Apostles no longer individually or in pairs beside each other but in interconnected and expressive groups.[27] As a result, in comparison with earlier or even with almost contemporary versions [32], Leonardo's scene is endowed with much more drama and

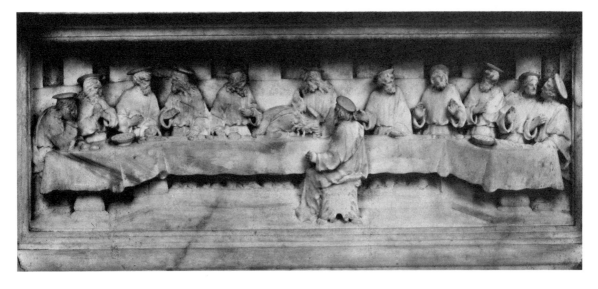

32. *The Last Supper*, *c.* 1485-90. Sansovino

33 (*opposite*). Sheet of studies, *c.* 1481. Leonardo

movement and is thereby significantly enhanced. Now it is highly revealing for Leonardo's free use of certain forms of expression of his own invention that in these first sketches for *The Last Supper* he quite openly adopts and remoulds an idea that he had already conceived many years earlier in a quite different context. Among his designs for the altarpiece of the *Adoration of the Magi* in the Uffizi, begun in 1481 in Florence and left behind there unfinished, a sheet in the Louvre shows a background scene of servants from the Magi's retinue conversing at table, three of them forming an integrated group [33]. It is noteworthy that below this group, and obviously

therefore arising out of the same thought, there is a Christ pointing to his plate, the Christ of the Last Supper, who utters the words 'He that putteth his hand with me in the dish, the same shall betray me' (Matthew xxvi, 23).

A long road leads from this first early inspiration, which came to Leonardo when he was occupied with a totally different task, to the shaping of the present theme almost fifteen years later. We see from the grouping of the Apostles how persistently an artistic idea once conceived, although in an entirely different context, remained rooted in Leonardo's mind, and came again to the fore at the requisite moment, as if in response to a summons, to fulfil its new function.

However, between these preliminary studies and the execution of the picture a second, and more profound transformation of the basic idea took place. This was in the precise moment in the Gospel account which he chose to illustrate. What we see in the painting is not, as was usual, the dramatic instant of the traitor's identification, but the immediately preceding and even more significant moment: the first and to the disciples still mysterious reference to treachery: 'Amen dico vobis quia unus vestrum me traditurus est' – 'Verily I say unto you that one of you shall betray me'.[28] In the Gospel (Matthew xxvi, 21) it goes on to say 'And they were exceeding sorrowful, and began every one of them to say unto him, Lord, is it I?' This is expanded in John xiii, 22 ff: 'And the disciples looked one on another, doubting of whom he spake. Now there was leaning on Jesus' bosom one of his disciples, whom Jesus loved. Simon Peter therefore beckoned to him, that he should ask who it should be of whom he spake.'

This new and truly great idea must have occurred to Leonardo from his own direct study of the Gospels. We possess no preparatory drawing of the composition as a whole that has any bearing on this decisive alteration, while on the other hand all the detail studies for the Apostles' heads, with the exception of the Vienna St Peter

which belongs to the first project [14], correspond with the finished painting [34] and thus also with the new conception. Leonardo appears to have been the first to have chosen this shattering moment,

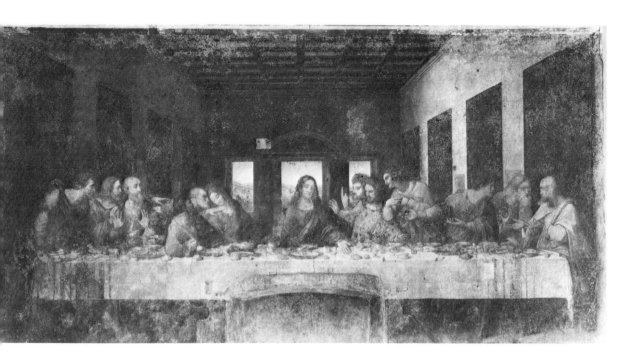

34. *The Last Supper*, 1494–8. Leonardo

the first indication of the betrayal *before* the identification of Judas, as a theme for his Last Supper, and he thereby shifted the whole emphasis from the outward effect (the identification of Judas) to the inner motivation, the prophetic words needed to produce the result. Every expression and every gesture, each individual figure or group is related to this most tense moment and gains thereby in content and meaning. But at the same time the composition – freely and naturally though it seems to fit together – observes a strict, carefully thought-out arrangement that takes account of the company of the disciples as a whole and of their relations to each other and among themselves down to the last detail. Thus all the twelve

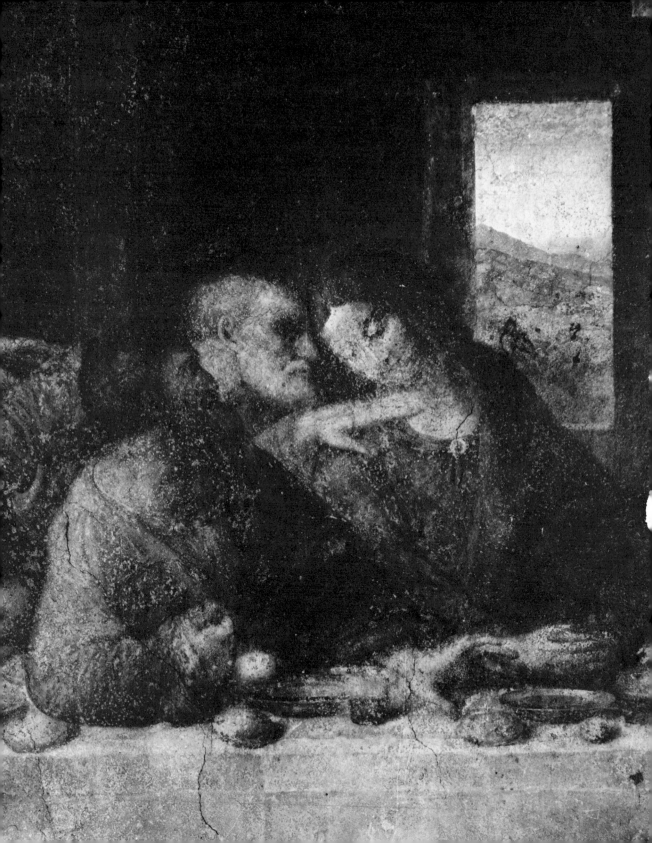

35 (*opposite*). Judas, St Peter
and St John,
detail from *The Last Supper*

36. Study for Judas,
1494-7. Leonardo

37. Study for the hands
of St John, 1494-7. Leonardo

38 (*below right*). Study for the arm
of St Peter, 1494-7. Leonardo

Apostles, again for the first time in the centuries-old history of pictures of the subject, are individually distinguished one from another, not just by the indication of their names or by outward attributes but by the portrayal of their specific qualities as they are known to us from the Gospels, the liturgies of their feasts and from legend.[29]

Let us call to mind the groups and individual figures: to the left of Christ sit first John and, prompting him, Peter, while Judas leans backward between them [35, 36, 37, 38]. Next comes Andrew, Peter's brother, then James the Greater, the elder brother of John; he touches Peter's shoulder and thus forms a link with Peter and John. These are the true Apostles who witnessed the Transfiguration

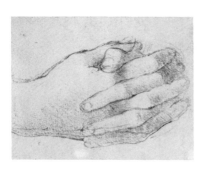

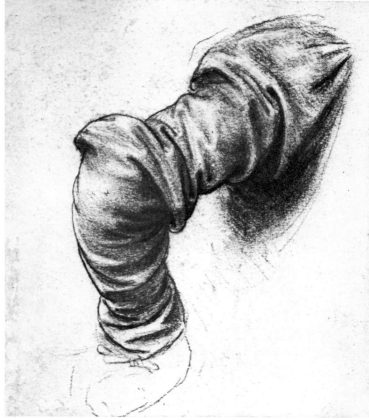

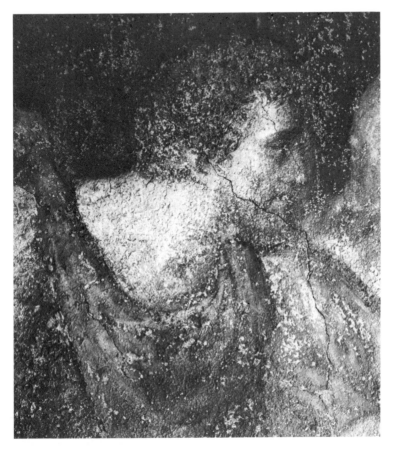

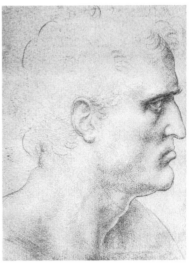

39 (*left*). St Bartholomew, detail from *The Last Supper*

40 (*above*). Study for St Bartholomew, 1494-7. Leonardo

41 (*opposite*). St Thomas, St James the Less and St Philip, detail from *The Last Supper*

and who accompanied Jesus to the Garden of Gethsemane (Matthew xvii,1 and xxvi, 36-7). At the end of the table stands Bartholomew, the steward [39, 40]. To the right of Christ sits James the Less, 'the Lord's brother' (Galatians i, 19), like him in feature and also with outspread arms, though his gesture is only a reaction, whereas in Christ it is the expression of a just completed action itself. Behind James the Less stands the doubting Thomas with upraised finger, and alongside him Philip, who, when supper was over joined with Thomas (according to John xiv, 5-8) in putting questions to Jesus [41, 42, 43]. James and Philip have also a link, in that they share a common feast-day.

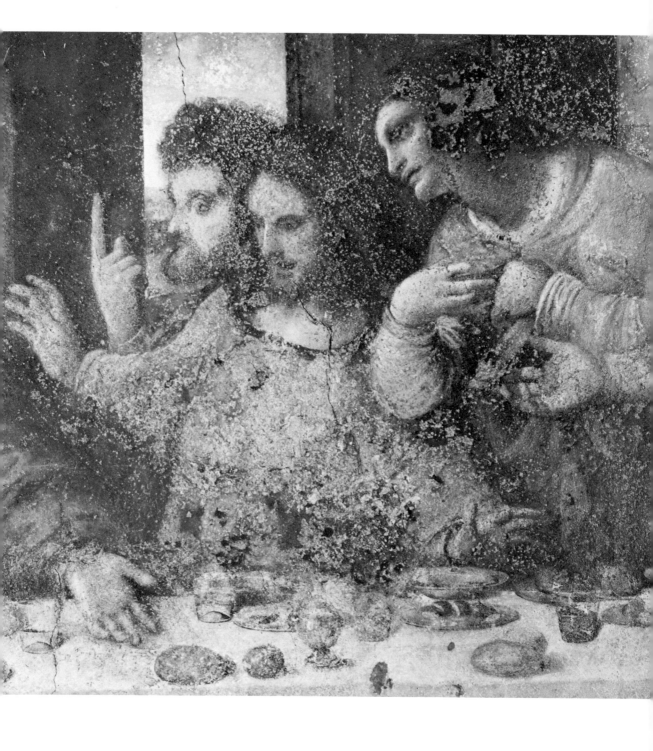

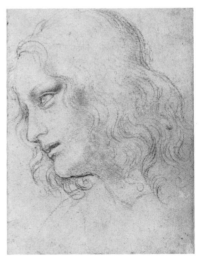

42 (*left*). Study for St James the Less,
1494–7. Leonardo

43 (*above*). Study for St Philip,
1494–7. Leonardo

44 (*opposite*). St Matthew, St Jude
and St Simon,
detail from *The Last Supper*

This group is followed by St Matthew, and lastly come St Jude,
brother of James the Less, and St Simon [44]; these two disciples
were martyred together so that they too have a single feast. Thus
not only are the Apostles arranged in four groups, according to

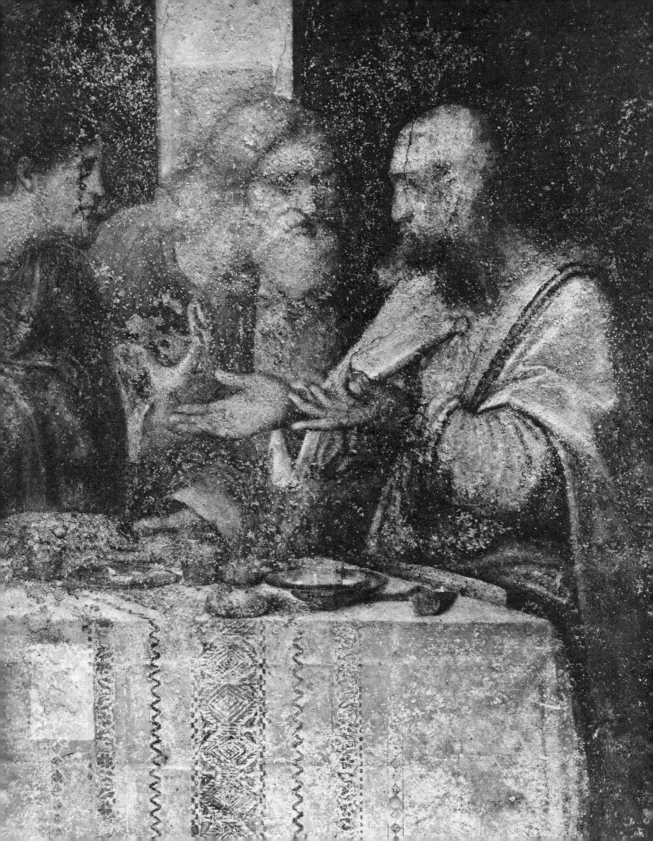

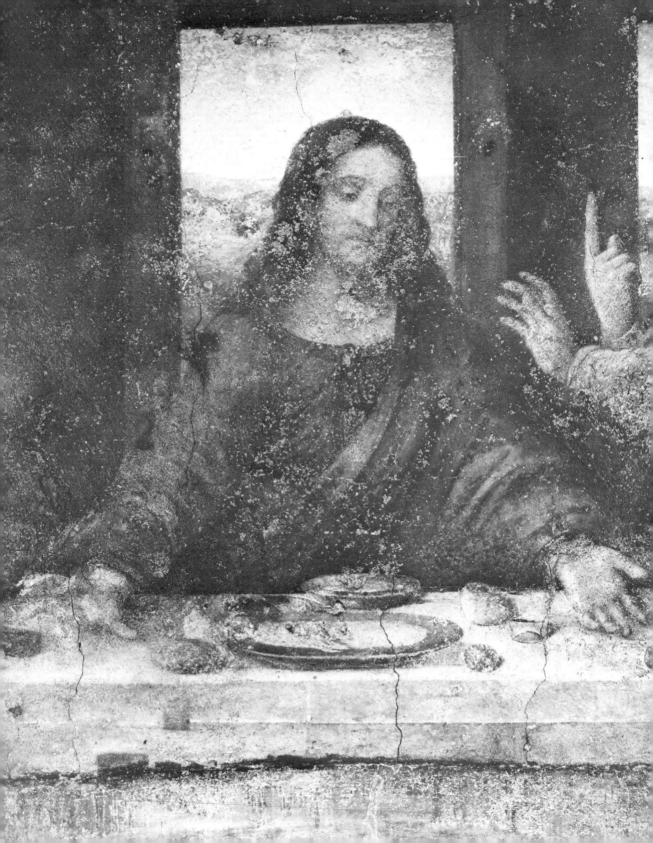

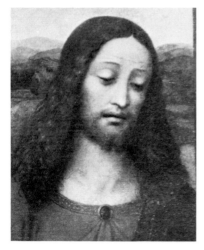 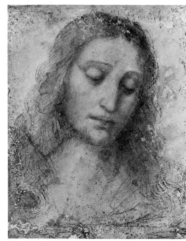 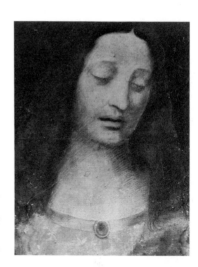

45 (*opposite*). Christ,
detail from *The Last Supper*

46. Detail from a copy of
The Last Supper, *c.* 1510-14

47. *Head of Christ.*
Follower of Leonardo

48. *Head of Christ.*
Follower of Leonardo

kinship and the personal links between them, but each of the twelve, taken individually, also exhibits an emotional and temperamental reaction appropriate to the character attributed to him in the Gospel text. Goethe (see Appendix 2) gives such a masterly interpretation of what is taking place that we can confine ourselves to the bare essentials.

Christ has uttered the words: 'Verily, verily, I say unto you that one of you shall betray me!' The Apostles are horrified; among his shocked and questioning disciples only Christ remains tranquil and composed. And so we see him [45, 46, 47, 48] – in the midst of his most faithful followers, who are after all only men, able to grasp the external event but without understanding its inner meaning – as the suddenly isolated God, alone in the knowledge of his destiny which only he can see as sacrifice and mystery. All the disciples react, each in his own way, as men. Their excitement increases to right and to left; the wave of emotion – expressing itself both in bodies and hands – moves outward and at the same time back to the centre.[30] Engulfing all but Christ, it leaves only one other unaffected: Judas. Remaining outside the circle of those innocently smitten, he, who alone shares the secret with Christ, is the second lone figure in

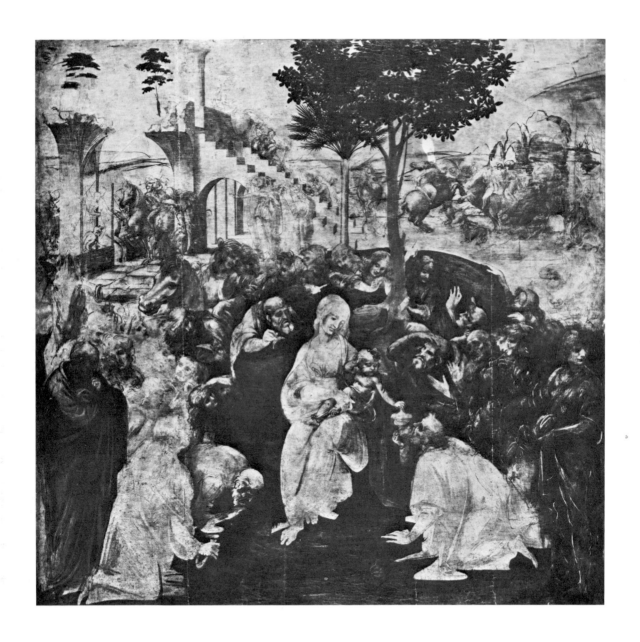

49. *The Adoration of the Magi, c.* 1481. Leonardo

the picture; but his isolation is due to guilt. Even though as yet they know nothing of his guilt, he is an outcast from the community, although outwardly he remains in close contact with them. He is more clearly abandoned than any earlier picture of the Last Supper had ever been able to express, although these do put Judas in emphatic isolation. He is the only one who sits in shadow; his sombre profile stands out darkly against the bright heads of the two favourite disciples, Peter and John, and the fateful connection with Christ, expressed in the hands that approach each other as well as in Judas's look, becomes at the same time an unbridgeable gulf. In such subtle differentiation of the characters of each Apostle Leonardo's art of expression reaches its climax. Here we are once again reminded of his great *Adoration of the Magi* [49] where his endeavour to grasp and represent the 'motions of the mind by gestures and movements' is manifested for the first time, particularly in the group of shepherds. Leonardo was deeply concerned with the problem of expression in art. And he committed some of his thoughts about it to paper:

'The movement of men are as varied as are the emotions which pass through their minds. And each emotion moves men more or less, depending on its greater or lesser force, and also on the age of the man, for in the same situation a young man will act otherwise than an old one.'

'Mental stimuli or thoughts produce in the body simple and easy action, and not great coming and going, for the object of attention is in the mind which, concentrated upon itself, does not direct the senses to bodily expression.'

'Emotions move the face of man in different ways, for one laughs, another weeps, one becomes gay, another sad, one shows anger, another pity, some are amazed, others are afraid, distracted, thoughtful or reflective. In these states the hands and the whole person should follow the expression of the face.'

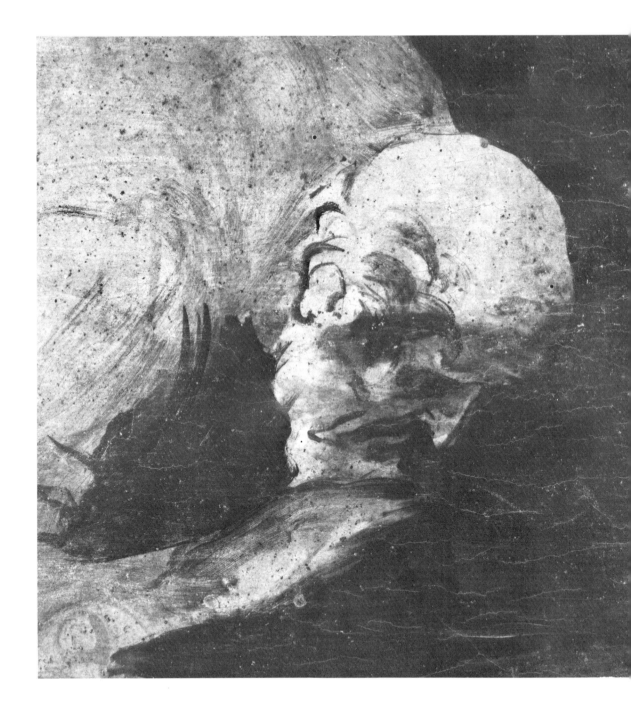

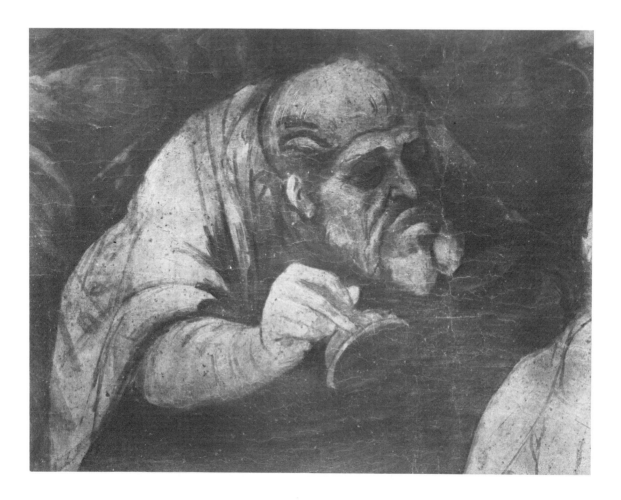

50 and 51. Detail of 49

These passages from Leonardo's *Treatise on Painting* might almost be read as a commentary on his own pictorial work. In facial expression and gesture the figures of the *Adoration* reflect all degrees of human feelings [50, 51]; but this multitude of juxtaposed faces is fused into a 'polyphony of emotion' which expresses a unity of wonder [52]. A similar 'polyphony of emotion' is again evident in the figures of the Apostles in *The Last Supper* [53]. In the differentiation of their individual features various 'emotions which pass through their minds' coalesce into a like unity. At the same time

each individual figure forms an integral part of mankind's response
to the words spoken by Christ.

Yet Leonardo's pictorial concept is not exhausted with the
portrayal of this dramatic moment of the announcement of the

52. Detail of 49

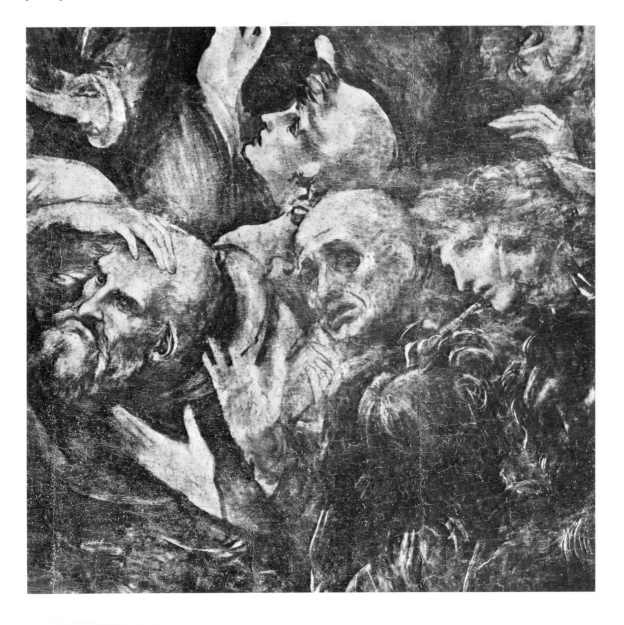

betrayal. On the contrary this 'episode' is only the framework designed to direct our thoughts to the essential meaning of the sacred scene, the institution of the eucharistic sacrifice.[31] The dominant position of Christ is impressively emphasized by the empty space

53. Detail of *The Last Supper*

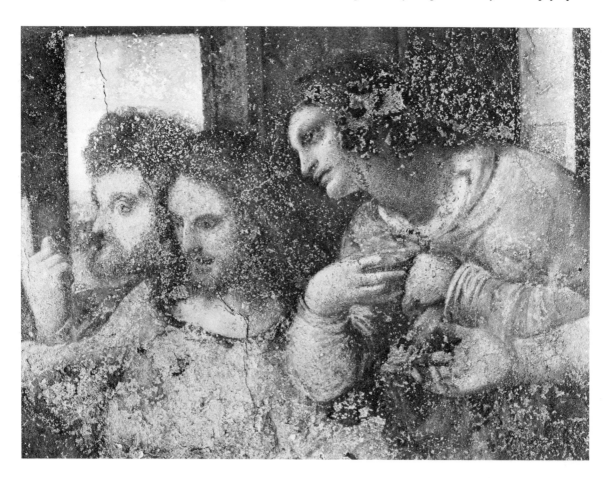

around him ('with no one crowding him, no one too close at his side', as Rubens says) and by the wonderful background motif of the pedimented doorway, which frames his figure against the view out into the countryside. Jesus lets both hands rest on the table: his left hand – lying between the cup and the still unbroken bread – seems to point with this silently expressive gesture to the bread

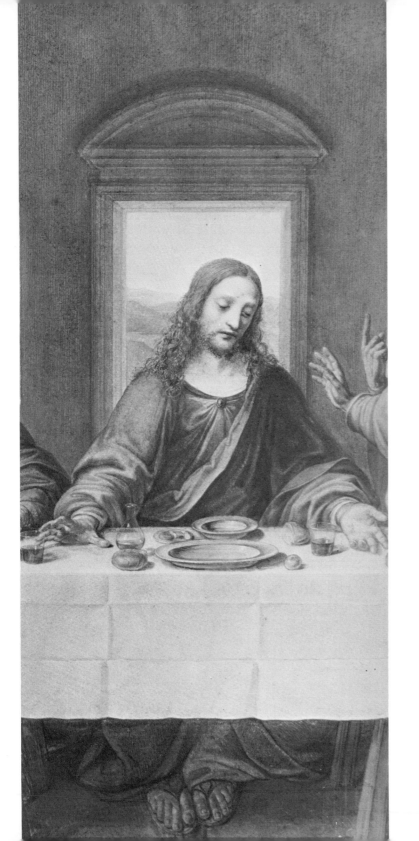

54. Detail of copy of
The Last Supper,
1794. André Dutertre

55 (*opposite*).
Detail of *The Last Supper*

and wine. His countenance and glance follow the same direction, thereby leading our attention also to the centre of action. And here we note another curious thing: the orderly arrangement of the objects on the table in front of Christ [54, 55]; immediately to the left and right of him they begin to fall into disarray.[32] Thus the space before the Lord is prepared, so to speak, for the sacred action which Christ – rising above the wave of emotion still seething round him among the disciples – is making ready to accomplish, submissive and sublime in the divine resolve, still hidden from his human companions, to offer himself as a sacrifice.

Thus in Leonardo's composition the age-old striving to combine the event of the Passion with the institution of the sacrament finds a new and uniquely effective solution.[33] Never has the symbolic element in this event been represented more humanly, more nobly or more simply. Deep insight into humanity and the ways in which its various qualities find expression was needed – and here we re-

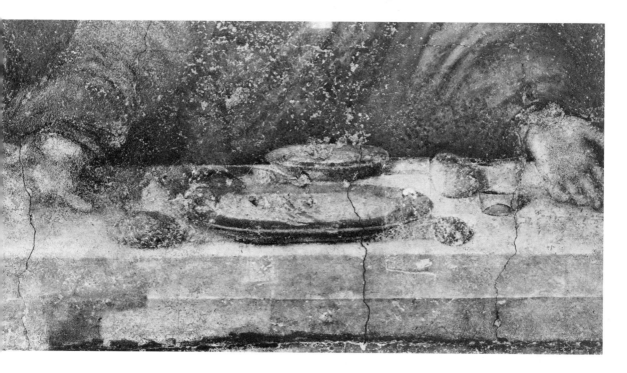

call once again the words of Rubens – to express this in the figures of the Apostles with such rich variety and force. Apart from the two preparatory sketches for the composition as a whole, the studies for the Apostles' heads are the only remaining evidence for Leonardo's preliminary work, although it must certainly have been unusually intensive.

So far we have spoken exclusively of the content of the work, but its fame rests equally on its perfection of form. Leonardo's *Last Supper* is a masterpiece of composition on a monumental scale.

The scene is set in a relatively confined space. The figures who throng round the table are mighty ones; if they were to rise there would not be room enough for them. A principle of classical composition is here applied for the first time: the figures are oversized in relation to the surrounding space. It is true that the setting is strictly 'correct' from the standpoint of perspective construction: the simulated extension of the refectory demanded tectonically clear and unambiguous architecture for the room. Squaring of the floor, a coffered ceiling, tapestries on the walls, articulation of the window and the table are the apparently simple but in fact very carefully thought-out means adopted to produce this effect. An artistic device is used here which completely changes the relation between the group of figures and the surrounding space without offending against the laws of perspective construction: the painted border surrounding the scene cuts so much off the ceiling and also the side walls that the table and figures appear to spring forward *in front of* the setting and thus seem to form part of the refectory itself. This artistic device is accompanied by another: the figures are not arranged in accordance with the vanishing line of the architecture; on the contrary each figure or group is depicted as if it had its own frontal plane and were being looked at *en face*. Besides these two modifying factors Leonardo made use, as we have seen, of oversized figures. Within the given space they possess a supernatural size; their existence seems to demand more room than they have at

their disposal. And it is this space-demanding force, implicit in their movements, which is one of the causes underlying the picture's monumental effect.

The careful application of the laws of geometrical perspective is complemented and heightened by the perspective of atmosphere and colour that Leonardo never tires of developing and expounding in his *Treatise on Painting*.

'The first task of painting is that the objects it presents should appear in relief, and that through the use of the three perspectives, the backgrounds surrounding them with their several distances should appear to be contained within the wall on which the painting is created. These perspectives are diminution of the forms of objects, diminution of their magnitudes, and diminution of their colours. The first of these three perspectives originates in the eye; the other two derive from the air lying between the eye and the objects seen by the eye. The second task of painting is to create actions and varied postures appropriate to the figures, so that the men do not look like brothers.'

'If we see that the true quality of colours is known through light, it is to be concluded that where there is more light, the true quality of the illuminated colour is better seen; and where there is more darkness, the colour is tinged with the colour of that darkness. Therefore, painter, remember to show true colour in the illuminated parts of your painting.'

'Nothing ever looks to be its real colour, if the light which strikes it is not all of that colour.

'This assertion is demonstrated in the colours of draperies, where the illuminated sides of folds reflect and give light to the shadowed folds opposite, making them show their true colour. The same thing is done with the bay leaf when one colour gives light to another, and the contrary results when light is taken from another colour.'

'No colour that is reflected on the surface of another body will tinge that surface with only its own colour, but it will mingle with

the concurrence of the other reflected colours which rebound on the same place.'

Among the benefits of the most recent restoration of *The Last Supper* has been the invaluable gain that Leonardo's great skill with colour now exerts a direct and strong effect, even from the little that remains of the picture's original condition. The room lies in a muted yet clear illumination. There are two sources of light: the last gleams of the dying day, which enter from behind through the window with its charming view of the countryside; and the light coming from the left in front – from the window of the refectory itself. This makes it possible for Leonardo to give his group of figures, which stands between, so to speak, these two zones of light, a very finely graduated relief. His coloration is in the highest sense 'painting in tones of light'. The colours of Christ's garments – red tunic, blue cloak – are both reflected in the pewter plate in front of him; similarly the plate in front of Philip reflects the red of his cloak. The colours of the Apostles' robes are distributed across the painting in a wonderful gradation. To the right of Christ the pale green tunic of James the Less forms a transition between Christ's blue cloak and the red one of Philip, whose blue sleeves are a carefully considered shade brighter than the tone of Christ's cloak. In the second group on the right Matthew is clothed in bright blue, which together with Jude's ochre tunic and the carmine-violet shot effect of Simon's cloak forms a perfect three-note chord. The *changeant* robes of Simon anticipate the painting of Andrea del Sarto. A figure such as this shows him to have been heir to Leonardo in his use of colour.

In the group to the left of Christ, consisting of John, Peter and Judas, the traitor's isolation is also emphasized by the blending of colours: his grey-blue garment is the only one whose tone remains indefinite and dull; it forms an effective contrast to the strong hues of John's dark, rust-red cloak and bluish-green tunic and to the powerful dark blue of Peter's sleeve (over a little piece of carmine-coloured cloak behind the knife). In the outer left-hand group, which

stands in front of a darker background, even richer shades of colour are employed: Andrew, with a green cloak over a golden yellow undergarment, James the Greater, in reddish clothing, and Bartholomew, in a violet-blue tunic and dark olive cloak, form, in their stronger coloration, a carefully weighed equivalent to the outer right-hand group which stands in brighter light.

Thus the colours pass over from the pure primary tones in the clothing of Christ into increasingly subtle blends on each side; at each end they reach colour values soon afterwards to become characteristic of early Cinquecento painting in Florence – the phase in which the principles of the classical High Renaissance style were evolved.

Only now since the last restoration of *The Last Supper* has it become possible for us to understand fully the unbounded admiration expressed by the hyper-critical Florentines for Leonardo's mastery when, after his return there from Milan, he began to paint his *St Anne, Madonna and Child*.[34] It was the luminosity of his colours that became a model for the younger generation of artists, together with his perfect 'relievo' and 'sfumato', i.e. that mode of painting in the most delicate gradations of light and shade which lends substance to a picture painted on a flat surface. For it is on the interplay of light and colour, bright and dark, that a picture depends for its three-dimensional sculptural values, which in turn ensure its "naturalness' – the highest demand of contemporary artistic theory.

According to Leonardo this 'naturalness' also demands in the end – and here we come back once again to his art of expression – that 'harmony between mental and physical motion', as we have already seen.

This correspondence between physical movement and mental emotion is perfectly achieved in the scene of the Last Supper. The momentary pause between two great emotions – the horror of being startled out of tranquillity, the momentary stiffening at the extreme point of excitement, about to dissolve again at once into the cross currents of differing emotions – this 'transitory moment' between

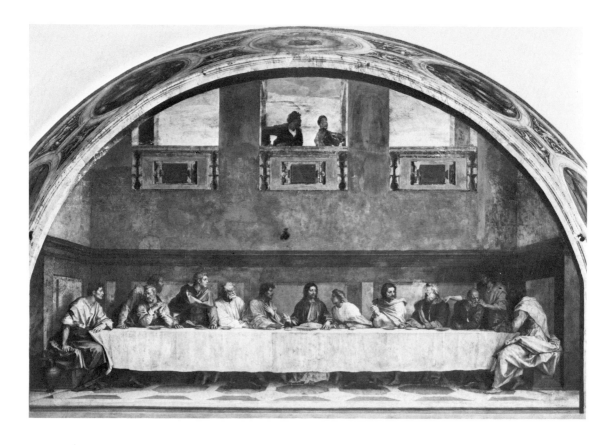

56. *The Last Supper*,
c. 1520–25. Andrea del Sarto

a preceding and a following action is fixed pictorially in a perfect form. The gradations of mimicry and gesture, of expression and emotion, the combination of types that complement each other in their outward or inward reactions – all this unites formal and thematic values in that perfection of effect which assured *The Last Supper* the unique fame which it has retained until this day.

This fame is attested not so much by the innumerable reproductions and – mostly somewhat weak – variations of the painting which begin with Leonardo's immediate successors, reach well into the Cinquecento and extend to France and the Netherlands, but rather by those works of great artists which are modelled on the 'Idea' of Leonardo's picture. We are not thinking so much of pictures like Andrea del Sarto's lively scene in S. Salvi [56], greatly as it is in-

debted to Leonardo and which in its turn influenced Raphael's composition as we know it from the engraving by Marc Antonio Raimondi. One can feel his influence more strongly in Titian's pathos-filled *Last Supper* in the Escorial [57]. But it is above all two of the great masters of Northern Europe who should be named here.

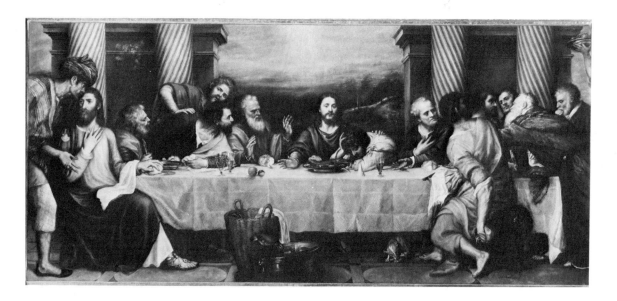

57. *The Last Supper*, 1564. Titian

Albrecht Dürer, in his late woodcut of 1523 [58], has given us one of the most striking and original variations on Leonardo's theme; and one which can be understood in a specifically Lutheran context[35]; and secondly the impressive and deeply moving drawing by Rembrandt, who never saw the original and only knew it from mediocre engravings and drawings [59]. It is in this drawing that we certainly find the most beautiful and harmonious adaptation that Leonardo's work has ever undergone.[36]

Round about 1800 the last phase in the fame of *The Last Supper* began. The impulses mentioned earlier on gave rise to the famous engravings by Raphael Morghen [6] and Giacomo Frey, which made their way all over the world. They have been joined by the innumerable reproductions produced in subsequent periods.

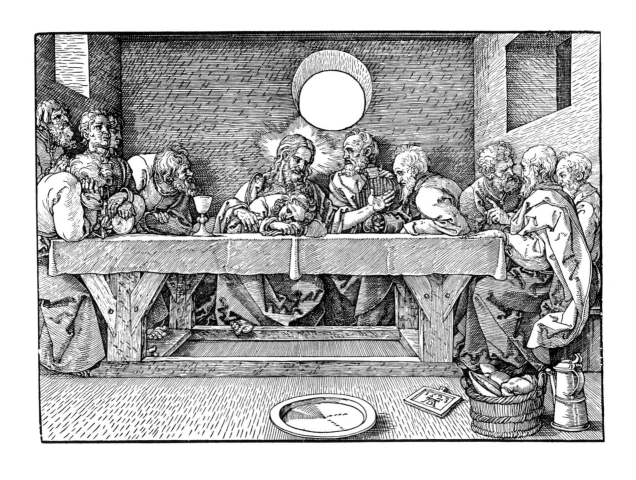

58. *The Last Supper*, 1523. Dürer

59 (*opposite*). *The Last Supper*, c. 1635. Rembrandt

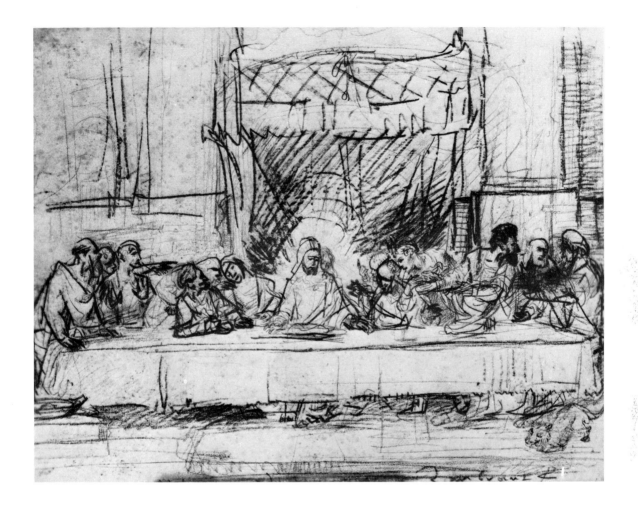

Thus Leonardo's *Last Supper* is one of the very few pictures of a Christian subject – perhaps the only one – that has become identified with its theme throughout the world. No other version, from Giotto through Raphael, Tintoretto, Rubens and down to Tiepolo, has been able to affect the absolute preeminence of Leonardo's achievement. His work has remained untouched by interdenominational strife and has maintained its effect unimpaired right down to the present.

Appendix 1:
The Gospel Accounts of the Last Supper,
from the Vulgate
and from the Douai Translation [37]

ST MATTHEW, CHAPTER XXVI, VERSES 20–30

20. But when it was evening, he sat down with his twelve disciples.

21. And whilst they were eating, he said: Amen I say to you, that one of you is about to betray me.

22. And they being very much troubled, began every one to say: Is it I, Lord?

23. But he answering, said: He that dippeth his hand with me in the dish, he shall betray me.

24. The Son of man indeed goeth, as it is written of him: but woe to that man by whom the Son of man shall be betrayed: it were better for him, if that man had not been born.

25. And Judas that betrayed him, answering, said: Is it I, Rabbi? He saith to him: Thou has said *it*.

26. And whilst they were at supper, Jesus took bread, and blessed, and broke: and gave to his disciples, and said: Take ye, and eat. This is my body.

27. And taking the chalice, he gave thanks, and gave to them, saying: Drink ye all of this.

28. For this is my blood of the new testament, which shall be shed for many unto remission of sins.

29. And I say to you, I will not drink from henceforth of this fruit of the vine, until that day when I shall drink it with you new in the kingdom of my Father.

30. And a hymn being said, they went out unto mount Olivet.

20. Vespere autem facto, discumbebat cum duodecim discipulis suis.

21. Et edentibus illis, dixit: Amen dico vobis quia unus vestrum me traditurus est.

22. Et contristati valde, cœperunt singuli dicere: Numquid ego sum, Domine?

23. At ipse respondens, ait: Qui intingit mecum manum in paropside, hic me tradet.

24. Filius quidem hominis vadit, sicut scriptum est de illo; væ autem homini illi, per quem Filius hominis tradetur! bonum erat ei, si natus non fuisset homo ille.

25. Respondens autem Judas, qui tradidit eum, dixit: Numquid ego sum, Rabbi? Ait illi: Tu dixisti.

26. Cœnantibus autem eis, accepit Jesus panem, et benedixit, ac fregit, deditque discipulis suis, et ait: Accipite, et comedite; hoc est corpus meum.

27. Et accipiens calicem, gratias egit, et dedit illis, decens: Bibite ex hoc omnes.

28. Hic est enim sanguis meus novi testamenti, qui pro multis effundetur in remissionem peccatorum.

29. Dico autem vobis: non bibam amodo de hoc genimine vitis, usque in diem illum, cum illud bibam vobiscum novum in regno Patris mei.

30. Et hymno dicto, exierunt in montem Oliveti.

ST MARK, CHAPTER XIV, VERSES 12-26

12. Now on the first day of the unleavened bread, when they sacrificed the pasch, the disciples say to him: Whither wilt thou that we go, and prepare for thee to eat the pasch?

13. And he sendeth two of his disciples, and saith to them: Go ye into the city; and there shall meet you a man carrying a pitcher of water, follow him;

14. And whithersoever he shall go in, say to the master of the house, The master saith, Where is my refectory, where I may eat the pasch with my disciples?

15. And he will shew you a large dining room furnished; and there prepare ye for us.

16. And his disciples went their way, and came into the city; and they found as he had told them, and they prepared the pasch.

17. And when evening was come, he cometh with the twelve.

18. And when they were at table and eating, Jesus saith: Amen I say to you, one of you that eateth with me shall betray me.

19. But they began to be sorrowful, and to say to him one by one: Is it I?

20. Who saith to them: One of the twelve, who dippeth with me his hand in the dish.

21. And the Son of man indeed goeth, as it is written of him: but woe to that man by whom the Son of man shall be betrayed. It were better for him, if that man had not been born.

22. And whilst they were eating, Jesus took bread; and blessing, broke, and gave to them, and said: Take ye. This is my body.

23. And having taken the chalice, giving thanks, he gave *it* to them. And they all drank of it.

24. And he said to them: This is my blood of the new testament, which shall be shed for many.

25. Amen I say to you, that I will drink no more of the fruit of the vine, until that day when I shall drink it new in the kingdom of God.

26. And when they had said an hymn, they went forth to the mount of Olives.

ST MARK, CHAPTER XIV

12. Et primo die Azymorum, quando pascha immolabant, dicunt ei discipuli: Quo vis eamus, et paremus tibi ut manduces pascha?

13. Et mittit duos ex discipulis suis, et dicit eis: Ite in civitatem, et occurret vobis homo lagenam aquæ bajulans, sequimini eum;

14. Et quocumque introierit, dicite domino domus, quia Magister dicit: Ubi est refectio mea, ubi pascha cum discipulis meis manducem?

15. Et ipse vobis demonstrabit cœnaculum grande, stratum; et illic parate nobis.

16. Et abierunt discipuli ejus, et venerunt in civitatem; et invenerunt sicut dixerat illis, et paraverunt pascha.

17. Vespere autem facto, venit cum duodecim.

18. Et discumbentibus eis, et manducantibus, ait Jesus: Amen dico vobis, quia unus ex vobis tradet me, qui manducat mecum.

19. At illi cœperunt contristari, et dicere ei singulatim: Numquid ego?

20. Qui ait illis: Unus ex duodecim, qui intingit mecum manum in catino.

21. Et Filius quidem hominis vadit, sicut scriptum est de eo; væ autem homini illi, per quem Filius hominis tradetur! Bonum erat ei, si non esset natus homo ille.

22. Et manducantibus illis, accepit Jesus panem, et benedicens fregit, et dedit eis, et ait: Sumite, hoc est corpus meum.

23. Et accepto calice, gratias agens dedit eis, et biberunt ex illo omnes.

24. Et ait illis: Hic est sanguis meus novi Testamenti, qui pro multis effundetur.

25. Amen dico vobis, quia jam non bibam de hoc genimine vitis, usque in diem illum, cum illud bibam novum in regno Dei.

26. Et hymno dicto, exierunt in montem Olivarum.

ST LUKE, CHAPTER XXII, VERSES 7–38

7. And the day of the unleavened bread came, on which it was necessary that the pasch should be killed.

8. And he sent Peter and John, saying: Go, and prepare for us the pasch, that we may eat.

9. But they said: Where wilt thou that we prepare?

10. And he said to them: Behold, as you go into the city, there shall meet you a man carrying a pitcher of water: follow him into the house where he entereth in.

11. And you shall say to the goodman of the house: The master saith to thee, Where is the guest chamber, where I may eat the pasch with my disciples?

12. And he will shew you a large dining room, furnished; and there prepare.

13. And they going, found as he had said to them, and made ready the pasch.

14. And when the hour was come, he sat down, and the twelve apostles with him.

15. And he said to them: With desire I have desired to eat this pasch with you, before I suffer.

16. For I say to you, that from this time I will not eat it, till it be fulfilled in the kingdom of God.

17. And having taken the chalice, he gave thanks, and said: Take, and divide *it* among you:

18. For I say to you, that I will not drink of the fruit of the vine, till the kingdom of God come.

19. And taking bread, he gave thanks, and brake; and gave to them, saying: This is my body, which is given for you. Do this for a commemoration of me.

20. In like manner the chalice also, after he had supped, saying: This is the chalice, the new testament in my blood, which shall be shed for you.

21. But yet behold, the hand of him that betrayeth me is with me on the table.

22. And the Son of man indeed goeth, according to that which is determined: but yet, woe to that man by whom he shall be betrayed.

23. And they began to inquire among themselves, which of them it was that should do this thing.

24. And there was also strife amongst them, which of them should seem to be the greater.

25. And he said to them: The kings of the Gentiles lord it over them; and they that have power over them, are called beneficent.

26. But you not so: but he that is the greater among you, let him become as the younger; and he that is the leader, as he that serveth.

27. For which is greater, he that sitteth at table, or he that serveth? Is not he that sitteth at table? But I am in the midst of you, as he that serveth:

28. And you are they who have continued with me in my temptations:

29. And I dispose to you, as my Father hath disposed to me, a kingdom;

30. That you may eat and drink at my table, in my kingdom: and may sit upon thrones, judging the twelve tribes of Israel.

31. And the Lord said: Simon, Simon, behold Satan hath desired to have you, that he may sift you as wheat:

32. But I have prayed for thee, that thy faith fail not: and thou, being once converted, confirm thy brethren.

33. Who said to him: Lord, I am ready to go with thee, both into prison, and to death.

34. And he said: I say to thee, Peter, the cock shall not crow this day, till thou thrice deniest that thou knowest me. And he said to them:

35. When I sent you without purse, and scrip, and shoes, did you want anything?

36. But they said: Nothing. Then said he unto them: But now he that hath a purse, let him take it, and likewise a scrip; and he that hath not, let him sell his coat, and buy a sword.

37. For I say to you, that this that is written must yet be fulfilled in me: *And with the wicked was he reckoned.* For the things concerning me have an end.

38. But they said, Lord, behold here *are* two swords. And he said to them, It is enough.

7. Venit autem dies Azymorum, in qua necesse erat occidi pascha.

8. Et misit Petrum et Joannem, dicens: Euntes parate nobis pascha, ut manducemus.

9. At illis dixerunt: Ubi vis paremus?

10. Et dixit ad eos: Ecce introeuntibus vobis in civitatem, occurret vobis homo quidam amphoram aquæ portans; sequimini eum in in domum, in quam intrat,

11. Et dicetis patrifamilias domus: Dicit tibi Magister: Ubi est diversorium, ubi pascha cum discipulis meis manducem?

12. Et ipse ostendet vobis cœnaculum magnum stratum; et ibi parate.

13. Euntes autem, invenerunt sicut dixit illis, et paraverunt pascha.

14. Et cum facta esset hora, discubuit, et duodecim apostoli cum eo.

15. Et ait illis: Desiderio desideravi hoc pascha manducare vobiscum, antequam patiar.

16. Dico enim vobis, quia ex hoc non manducabo illud, donec impleatur in regno Dei.

17. Et accepto calice, gratias egit, et dixit: Accipite, et dividite inter vos.

18. Dico enim vobis quod non bibam de generatione vitis, donec regnum Dei veniat.

19. Et accepto pane, gratias egit, et fregit, et dedit eis, dicens: Hoc est corpus meum, quod pro vobis datur; hoc facite in meam commemorationem.

20. Similiter et calicem, postquam cœnavit, dicens: Hic est calix novum testamentum in sanguine meo, qui pro vobis fundetur.

21. Verumtamen ecce manus tradentis me mecum est in mensa.

22. Et quidem Filius hominis, secundum quod definitum est, vadit; verumtamen væ homini illi, per quem tradetur.

23. Et ipsi cœperunt quærere inter se, quis esset ex eis, qui hoc facturus esset.

24. Facta est autem et contentio inter eos, quis eorum videretur esse major.

25. Dixit autem eis: Reges gentium dominantur eorum, et qui potestatem habent super eos, benefici vocantur.

26. Vos autem non sic; sed qui major est in vobis, fiat sicut minor; et qui præcessor est, sicut ministrator.

27. Nam quis major est, qui recumbit, an qui ministrat? nonne qui recumbit? Ego autem in medio vestrum sum, sicut qui ministrat.

28. Vos autem estis, qui permansistis mecum in tentationibus meis;

29. Et ego dispono vobis sicut disposuit mihi Pater meus regnum,

30. Ut edatis et bibatis super mensam meam in regno meo, et sedeatis super thronos, judicantes duodecim tribus Israel.

31. Ait autem Dominus: Simon, Simon, ecce Satanas expetivit vos ut cribraret sicut triticum;

32. Ego autem rogavi pro te ut non deficiat fides tua; et tu aliquando conversus confirma fratres tuos.

33. Qui dixit ei: Domine, tecum paratus sum et in carcerem et in mortem ire.

34. At ille dixit: Dico tibi, Petre, non cantabit hodie gallus, donec ter abneges nosse me. Et dixit eis:

35. Quando misi vos sine sacculo, et pera, et calceamentis, numquid aliquid defuit vobis?

36. At illi dixerunt: Nihil. Dixit ergo eis: Sed nunc, qui habet sacculum, tollat, similiter et peram; et qui non habet, vendat tunicam suam, et emat gladium.

37. Dico enim vobis, quoniam adhuc hoc quod scriptum est, oportet impleri in me: Et cum iniquis deputatus est. Etenim ea, quæ sunt de me, finem habent.

38. At illi dixerunt: Domine, ecce duo gladii hic. At ille dixit eis: Satis est.

ST JOHN, CHAPTER XIII, VERSES 1-30

1. Before the festival day of the pasch, Jesus knowing that his hour was come, that he should pass out of this world to the Father: having loved his own who were in the world, he loved them unto the end.

2. And when supper was done, (the devil having now put into the heart of Judas Iscariot, the son of Simon, to betray him,)

3. Knowing that the Father had given him all things into his hands, and that he came from God, and goeth to God,

4. He riseth from supper, and layeth aside his garments, and having taken a towel, girded himself.

5. After that, he putteth water into a basin, and began to wash the feet of the disciples, and to wipe them with the towel wherewith he was girded.

6. He cometh therefore to Simon Peter. And Peter saith to him: Lord, dost thou wash my feet?

7. Jesus answered, and said to him: What I do thou knowest not now; but thou shalt know hereafter.

8. Peter saith to him: Thou shalt never wash my feet. Jesus answered him: If I wash thee not, thou shalt have no part with me.

9. Simon Peter saith to him: Lord, not only my feet, but also my hands and my head.

10. Jesus saith to him: He that is washed, needeth not but to wash his feet, but is clean wholly. And you are clean, but not all.

11. For he knew who he was that would betray him; therefore he said: You are not all clean.

12. Then after he had washed their feet, and taken his garments, being set down again, he said to them: Know you what I have done to you?

13. You call me Master, and Lord; and you say well, for so I am.

14. If then I being *your* Lord and Master, have washed your feet; you also ought to wash one another's feet.

15. For I have given you an example, that as I have done to you, so you do also.

16. Amen, amen I say to you: The servant is not greater than his lord; neither is the apostle greater than he that sent him.

17. If you know these things, you shall be blessed if you do them.

18. I speak not of you all: I know whom I have chosen. But that the scripture may be fulfilled: *He that eateth bread with me, shall lift up his heel against me.*

19. At present I tell you, before it come to pass: that when it shall come to pass, you may believe that I am he.

20. Amen, amen I say to you, he that receiveth whomsoever I send, receiveth me; and he that receiveth me, receiveth him that sent me.

21. When Jesus had said these things, he was troubled in spirit; and he testified, and said: Amen, amen I say to you, one of you shall betray me.

22. The disciples therefore looked one upon another, doubting of whom he spoke.

23. Now there was leaning on Jesus' bosom one of his disciples, whom Jesus loved.

24. Simon Peter therefore beckoned to him, and said to him: Who is it of whom he speaketh?

25. He therefore, leaning on the breast of Jesus, saith to him: Lord, who is it?

26. Jesus answered: He it is to whom I shall reach bread dipped. And when he had dipped the bread, he gave it to Judas Iscariot, *the son* of Simon.

27. And after the morsel, Satan entered into him. And Jesus said to him; That which thou dost, do quickly.

28. Now no man at the table knew to what purpose he said this unto him.

29. For some thought, because Judas had the purse, that Jesus had said to him: Buy those things which we have need of for the festival day: or that he should give something to the poor.

30. He therefore having received the morsel, went out immediately. And it was night.

ST JOHN, CHAPTER XIII

1. Ante diem festum Paschæ, sciens Jesus quia venit hora ejus ut transeat ex hoc mundo ad Patrem, cum dilexisset suos, qui erant in mundo, in finem dilexit eos.

2. Et cœna facta, cum diabolus jain misisset in cor, ut traderet eum Judas Simonis Iscariotæ,

3. Sciens quia omnia dedit ei Pater in manus, et quia a Deo exivit, et ad Deum vadit,

4. Surgit a cœna, et ponit vestimenta sua, et cum accepisset linteum, præcinxit se.

5. Deinde mittit aquam in pelvim, et cœpit lavare pedes discipulorum, et extergere linteo, quo erat præcinctus.

6. Venit ergo ad Simonem Petrum. Et dicit ei Petrus: Domine, tu mihi lavas pedes?

7. Respondit Jesus, et dixit ei: Quod ego facio, tu nescis modo, scies autem postea.

8. Dicit ei Petrus: Non lavabis mihi pedes in æternum. Respondit ei Jesus: Si non lavero te, non habebis partem mecum.

9. Dicit ei Simon Petrus: Domine, non tantum pedes meos, sed et manus, et caput.

10. Dicit ei Jesus: Qui lotus est, non indiget nisi ut pedes lavet, sed est mundus totus. Et vos mundi estis, sed non omnes.

11. Sciebat enim quisnam esset qui traderet eum; propterea dixit: Non estis mundi omnes.

12. Postquam ergo lavit pedes eorum, et accepit vestimenta sua, cum recubuisset iterum, dixit eis: Scitis quid fecerim vobis?

13. Vos vocatis me: Magister, et Domine; et bene dicitis; sum etenim.

14. Si ergo ego lavi pedes vestros Dominus et Magister, et vos debetis alter alterius lavare pedes.

15. Exemplum enim dedi vobis, ut quemadmodum ego feci vobis, ita et vos faciatis.

16. Amen, amen dico vobis: Non est servus major domino suo; neque apostolus major est eo qui misit illum.

17. Si hæc scitis, beati eritis si feceritis ea.

18. Non de omnibus vobis dico; ego scio quos elegerim; sed ut adimpleatur Scriptura: Qui manducat mecum panem, levabit contra me calcaneum suum.

19. Amodo dico vobis, priusquam fiat, ut cum actum fuerit, credatis quia ego sum.

20. Amen, amen dico vobis: Qui accipit si quem misero, me accipit; qui autem me accipit, accipit eum qui me misit.

21. Cum hæc dixisset Jesus, turbatus est spiritu, et protestatus est, et dixit: Amen, amen dico vobis, quia unus ex vobis tradet me.

22. Aspeciebant ergo ad invicem discipuli, hæsitantes de quo diceret.

23. Erat ergo recumbens unus ex discipulis ejus in sinu Jesu, quem diligebat Jesus.

24. Innuit ergo huic Simon Petrus, et dixit ei: Quis est, de quo dicit?

25. Itaque cum recubuisset ille supra pectus Jesu, dicit ei: Domine, quis est?

26. Respondit Jesus: Ille est cui ego intinctum panem porrexero. Et cum intinxisset panem, dedit Judæ Simonis Iscariotæ.

27. Est post buccellam, introivit in eum Satanas. Et dixit ei Jesus: Quod facis, fac citius.

28. Hoc autem nemo scivit discumbentium ad quid dixerit ei.

29. Quidam enim putabant, quia loculos habebat Judas, quod dixisset ei Jesus: Eme ea, quæ opus sunt nobis ad diem festum; aut egenis ut aliquid daret.

30. Cum ergo accepisset ille buccellam, exivit continuo. Erat autem nox.

Appendix 2:
Goethe and Leonardo's Last Supper

Goethe saw Leonardo's *Last Supper* in May 1788 when he stopped in Milan on his way north on leaving Italy, but of course he already knew it well from copies. Indeed he had mentioned the previous year his hopes of arranging in Rome for a print to be made from a copy he had seen there. 'It would be the greatest blessing if a faithful reproduction could become available to a wide public.' After seeing the original he wrote to his friend and patron Duke Karl August of Weimar on 23 May 1788: 'Leonardo's *Last Supper* is truly a key-work in the sphere of artistic conceptions. It is quite unique and there is nothing that can be compared to it.'

His famous description of it was written almost thirty years later, being published in 1817 as part of a book review or rather essay: 'Joseph Bossi über Leonards da Vinci Abendmahl zu Mailand' in *Über Kunst und Alterthum*, III, Weimar, 1817.

The following translation is by G. H. Noehden and was first published in his *Observations on Leonardo da Vinci's Celebrated Picture of The Last Supper. By J. W. de Goethe translated by G. H. Noehden*, London, 1821. Noehden spent the winter of 1818–19 in Weimar and his translation was approved by Goethe: see Lavinia Mazzucchetti, *Goethe e il Cenacolo di Leonardo*, Milan, 1939.

THE LAST SUPPER

We now come to what is the particular object of our attention, The Last Supper of our Lord, which was painted upon the wall, in the convent *alle Grazie*, at Milan. If the reader will please to take before

him Morghen's print,* it will enable him to understand our remarks, both in the whole, and in detail.

The place, where the picture was painted, is first to be considered: for here the judgment of the artist appears to the greatest advantage. There is hardly a subject that could be fitter, and more becoming, for the refectory of a holy fraternity, than the parting meal, which was to be a sacred remembrance for all ages to come.

We have, in our travels, seen this refectory, several years ago, yet undestroyed. Opposite to the entrance, at the bottom, on the narrow side of the room, stood the Prior's table; on both sides of it, along the walls, the tables of the monks, raised, like the Prior's, a step above the ground: and now, when the stranger, that might enter the room, turned himself about, he saw, on the fourth wall, over the door, not very high, a fourth table, painted, at which Christ and his Disciples were seated, as if they formed part of the company. It must, at the hour of the meal, have been an interesting sight, to view the tables of the Prior and Christ, thus facing each other, as two counterparts, and the monks at their board, enclosed between them. For this reason, it was consonant with the judgment of the painter to take the tables of the monks as models; and there is no doubt, that the table-cloth, with its pleated folds, its stripes and figures, and even the knots, at the corners, was borrowed from the laundry of the convent. Dishes, plates, cups, and other utensils, were, probably, likewise copied from those, which the monks made use of.

There was, consequently, no idea of imitating some ancient and uncertain costume. It would have been unsuitable, in the extreme, in this place, to lay the holy company on couches: on the contrary, it was to be assimilated to those present. Christ was to celebrate his last supper, among the Dominicans, at Milan.

*Any other print would, of course, equally answer this purpose of reference. The smallest by Mocchetti would have suited the present publication, and I regret I am not furnished with a sufficient number of these prints, to give them as accompaniments. I have six of them, and can accordingly only supply with them so many copies. (Trans.)

In several other respects also was the picture calculated to produce a great effect. Being raised about ten feet* above the ground, the thirteen figures, exceeding by nearly one half the natural size, occupy the space of twenty-eight feet, Parisian measure, in length. Two of them only, at the opposite ends of the table, are seen entire: the rest are half figures, but even here the artist derived an advantage from the necessity of his situation. Every moral expression appertains only to the upper part of the body: the feet are, in such cases, generally in the way. Here the artist produced eleven half figures, of which the thighs and knees are covered by the table and table-cloth, and the feet below are scarcely noticed, in their modest obscurity.

Transfer yourself into this place, and picture to your mind the decorous and indisturbed calm, which reigns in such a monkish refectory; then you will admire the artist who knew how to inspire into his work a powerful emotion and active life, and, while approximating it to nature, as much as possible, at the same time, effected a contrast with the scenes of real existence, that immediately surrounded it.

The means of excitement, which he employed to agitate the holy and tranquil company, at table, are the words of the Master, *There is one among you that betrays me.* The words are uttered, and the whole company is thrown into consternation: but *he* inclines his head, with bent-down look, while the whole attitude, the motion of the arms, the hands, and every thing, seems to repeat the inauspicious expressions, which silence itself confirms: *Verily, verily, there is one among you that betrays me.*

But, before we proceed any farther, let us analyse one great expedient, whereby Leonardo chiefly enlivened his picture: it is the motion of the hands. This resource was obvious to an Italian. In this nation, the whole body is animated, every member, every limb participates

* According to my measurement, the picture is only about 8 feet raised above the ground, and its extent, in width, along the wall, exceeds 28. (Trans.)

in any expression of feeling, of passion, and even of thought. By a varied position and motion of the hands, the Italian signifies: *What do I care! – Come! – This is a rogue – take care of him! – His life shall not be long! – This is the point! – Attend to this, ye that hear me!*

Such a national peculiarity could not but attract the notice of Leonardo, who was, in the highest degree, alive to every thing, that appeared characteristick, and, in this particular, the picture before us, is strikingly distinguished, so that it is impossible, with this view, sufficiently to contemplate it. The countenance and action are in perfect unison, and there seems to be a co-operation of the parts, and at the same time, a contrast, most admirably harmonized.

The figures, on both sides of our Lord, may be considered by *threes* together, and thus they appear, as if formed into *unities*, corresponding, in a certain relation, with each other. Next to Christ, on the right hand, are *John*, *Judas*, and *Peter*.

Peter, the farthest, when he has heard the words of the Lord, rises quickly, in conformity with his vehement character, behind *Judas*, who, terrified and looking upwards, leans over the table, holding the purse with his right hand, which is tightly compressed, but making, with his left, an unvoluntary convulsive motion, as if to say, *what is the matter? what is to happen?* Peter, in the mean time, has, with his left hand, grasped the right shoulder of *John*, who is bending towards him, and pointing to Christ, seems to signify to the beloved disciple, that he should ask, who is the traitor. Holding a knife in his right hand, he accidentally, and without design, touches with the handle of it the side of Judas, by which the attitude of the latter, who is stooping forward, as if alarmed, and by this motion overturns a salt-cellar, is happily effected. This group may be regarded as the one first conceived in the picture; it is certainly the most perfect.

While on the right hand, with a certain degree of emotion, immediate revenge seems to be threatened, horrour and detestation of the treachery manifest themselves on the left. *James* the elder draws back, from terrour, spreads his arms, gazes, his head bent down,

like one who imagines that he already sees with his eyes those dreadful things, which he hears with his ears. *Thomas* appears from behind his shoulder, and, advancing towards the Saviour, lifts up the forefinger of the right hand towards his forehead. *Philip*, the third of this group, completes it in a most pleasing manner: he is risen, and bending forward, towards the Master, lays the hands upon his breast, as if distinctly pronouncing: *Lord, I am non he – Thou knowest it – Thou seest my pure heart – I am non he!*

And now the three last figures, on this side, afford new matter for contemplation. They are conversing together on the dire intelligence they have just received. *Matthew* turns his face, with an eager expression, to his two companions, on the left, while he extends his hands, with a quick motion, towards the Master; and thus unites his group, by an admirable contrivance, with the foregoing. *Thaddaeus* shows the utmost surprise, doubt, and suspicion: he has placed the left hand open on the table, and raised the right in such a manner, as if he were going to strike, with the back of it, into the left, a movement, which may sometimes be observed in common life, when at some unexpected occurrence a man would say, *Did I not tell you so! – Did I not always suspect it!* Simon sits, with great dignity, at the bottom of the table; his whole form, therefore, is to be seen. He, the oldest of all, is dressed in a full garment. His countenance and motion indicate that he is troubled, and in thought, though not agitated and terrified.

If we turn our eyes at once to the opposite end of the table, we see *Bartholomew*, who is standing on the right foot, the left being crossed over, his body bent forward, and supported with both hands, which are placed on the table. He listens, as if to hear what John may learn from the Lord: for altogether, the application to the favourite disciple seems to proceed from this side. *James* the younger, near Bartholomew, but behind him, puts his left hand upon the shoulder of Peter, in a similar manner as Peter had laid his on the shoulder of John; but James appears mild, as if only desiring information, whereas Peter seems to threaten vengeance. And, as Peter did be-

hind Judas, so James the younger stretches out his hands behind *Andrew*, who, being one of the most prominent figures, expresses, by his half uplifted arms, and outspread hands, the fixed horrour with which he is seized. This expression only occurs once in the picture, though it is sadly repeated in inferior works, composed with less genius and reflection.

Appendix 3:
Condition and Restoration

The long history of the many restorations of *The Last Supper* begins in 1726 with that by the painter Michelangelo Bellotti. There had presumably been earlier restorations for the picture's deplorable condition was well known and had been frequently commented on, as we have seen (p. 16f. above) from within a few years of its completion. Cardinal Federico Borromeo mentions in his *Musaeum Bibliothecae Ambrosianae* (Milan, 1625) that he discussed the problem of 'saving' the painting, but this appears to have resulted only in his commissioning a copy to be painted of it by Vespino (now in the Ambrosiana, Milan). There is, in fact, no record of any sixteenth- or seventeenth-century restoration.

Before recounting what little is known about Bellotti's restoration of 1726 (all trace of which was of course removed during subsequent restorations) it may be useful to give here Jonathan Richardson's account of the painting shortly before Bellotti began work on it.

'Milan, *The Monastery of the* Dominicans. In the Refectory over a very high door, is the famous Picture of the Last Supper, figures as big as the life; it is excessively ruin'd, and all the Apostles on the Right-hand of the *Christ* are entirely defaced; the *Christ* and those on his Left-hand appear pretty plain, but the Colours are quite faded, and in several Places only the bare Wall is left; that which is next but one to the *Christ* is the best preserved, (he that crosses his Hands upon his Breast) and has a marvellous Expression, much stronger than I have seen in any of the Drawings. *Armenini* (who wrote about the year 1580) says, this Picture was half spoil'd in his

time. That Story of the Head of the *Christ* being left unfinish'd, Lionardo conceiving it impossible for him to reach his Own Idea is certainly false, because one part of the Head which remains entire is highly finished in his usual manner. They have nail'd the Emperor's Arms over the *Christ's* Head so low that it almost touches his Hair, and hides a great part of the Picture.' (J. Richardson: *An Account of Some of the Statues, Bas-reliefs, Drawings and Pictures in Italy &ca with Remarks*. London, 1722, p. 23).

In the early eighteenth century it was thought, both because of Lomazzo's description of the painting and because of its surface appearance, that Leonardo had used oil paint. In 1726, therefore, Bellotti finished his work by giving the whole painting a coating of oil varnish. He was also said, by Carlo Bianconi (*Nuova Guida di Milano*, Milan, 1787, p. 329), to have repainted it from top to bottom but this seems to have been an exaggeration, though his restoration evidently included numerous retouchings, repaintings and reworkings of the original paint surface where necessary to accommodate his 'restored' areas. (These reworkings and repaintings were entirely scraped off by the next restorer, Giuseppe Mazza, but an example of Bellotti's own painting can still be seen on the façade of S.Maria delle Grazie where he painted in 1729 the fresco in the lunette above the main door.)

It is from contemporary reports on Mazza's restoration that much of what is known about Bellotti's work has been recorded. Earlier accounts, written while Bellotti's restoration was still visible, are very inconclusive. It was praised by S.Latuada ('fu però di nuovo con somma attenzione e pazienza ridotto a perfezione', *Descrizione di Milano*, Milan, 1738, vol. iv, p. 384), and Francesco Bartoli ('Bellotti Pittore, con un suo particolare segreto ha ravvivata questa pittura, e l'ha resa stimabile, bella quale fu un giorno', *Notizie delle Pitture, Sculture ed Architetture* &ca., Venice, 1776, p. 192); but it was severely criticized by Charles-Marie de La Condamine ('On est étonné de trouver aujourd'hui très-frais un

tableau qui parut si noir et si gâté à Misson il y a quatre-vingt ans, que ce voyageur assure qu'il n'y put rien distinguer. Il ne suffit donc pas supposer que depuis vingt-cinq ou trente ans il ait été nettoyé par un secret inconnu, comme on le dit aux voyageurs, mais il faut qu'il ait été repeint entièrement. C'est ce qui m'a été confirmé de bonne part. Il y a donc bien d'apparence que la belle ordonnance, le choix des attitudes, la distribution des figures, la composition en un mot est aujourd'hui presque la seule chose dans ce tableau qui appartienne bien sûrement à son premier auteur.' 'Extrait d'un journal de voyage en Italie' in *Histoire de l'Académie Royale de sciences*. Année 1757, Paris, 1762, p. 404) and by Carlo Bianconi ('Quindi lavatala, sicuramente con corosivi, e di poi redipinta la fece vedere quasi come nuova. Così resta coperta quel poco che a noi era rimasta di Lionardo, dal pennello, ci sià permesso il dire, dispregevole a fronte del primo, del Bellotti . . . Non è meglio l'avere un pezzo benchè guasto d'uno de' primi Pittori, de quello che sotto l'aspetto di falso rinovazione non avere che un empiastro vergognoso, e lontano dall'originale', *Nuova Guida di Milano*, Milan, 1787, p. 329). Bianconi also criticised Bellotti for not having kept any record of his work or of the process he employed. However, he would seem to have agreed, perhaps inadvertently and in any case only by implication, with Bellotti's defenders who claimed that he had not removed any of the original paint surface which remained when he began his restoration. For Bianconi stated that the original paint surface could still be seen in the three Apostles on the left, which were, as we shall see, the only part of the painting which Mazza did not touch but which had, of course, been restored by Bellotti.

By 1770 *The Last Supper* had again visibly deteriorated to such an extent that the Dominicans of S. Maria delle Grazie decided to embark on another attempt, this time employing the painter Giuseppe Mazza, an artist otherwise unknown. By chance the Irish painter James Barry visited Milan in 1770 and saw Mazza at work. He left a vivid description of it (see pp. 18–19 above) and it may have

been partly due to Barry that when it was realized that Mazza was using a scraper on the paint surface in order to erase Bellotti's re-paintings and retouchings, he was promptly halted by the Prior, Padre Galliani (himself a painter and former pupil of Lazzarini). Unfortunately, however, by the time Padre Galliani intervened Mazza had already scraped a great deal of the painting – all but three of the Apostles, in fact. Nevertheless, even Mazza was not without his defenders (see Emilio Motta, 'Il Restauro del Cenacolo nel Secolo XVIII e l'auto-difesa del Pittore Mazza' which prints the long defence by Giuseppe Frattini presented to Count Firmian on 20 May 1780, in *Raccolta Vinciana*, 1907, pp. 127-38).

Shortly after Napoleon established his Italian Republic (formerly the Cisalpine Republic) in Milan in 1802, the neo-classical painter Andrea Appiani carried out a detailed examination of *The Last Supper* and submitted a report to the Napoleonic government. He found – as had Padre Bosca in 1672 – that the chief cause of the painting's physical deterioration was the excessive humidity of the refectory, but he reported that it would, for various reasons, be im-possible to detach the painting from the wall and remove it to less humid conditions. He recommended that any restoration should be limited 'à reparer et assurer les croutes de cet œuvre'. (Report by Appiani 2 September 1802). In 1819, by which time Milan was under Austrian control, a further attempt at restoration was made. The Austrian authorities recommended that *The Last Supper* be protected with glass but the Accademia di Belle Arti in Milan was more ambitious. The painter-restorer Stefano Barezzi had recently successfully 'detached' frescoes from their supporting wall and transferred them to new supports. There had been earlier attempts to do this (e.g. by Antonio Contri of Ferrara at the beginning of the eighteenth century) but Barezzi had invented a new and successful method. (The novelty and success lay in the way he transferred the fresco to canvas rather than in the way he detached the fresco from the wall. The best known example of his method is the series of Luini frescoes from the Villa Pelucca near Monza which he detached

in 1821-2. They are now in the Brera, Milan). Barezzi proposed to the Accademia that he detach *The Last Supper* from the wall and his proposal was favourably received. But the Austrian authorities advocated caution and Barezzi was instructed to make a preliminary experiment on a small section of the table cloth. Unfortunately, he exceeded his instructions and experimented on an area which included one of Christ's hands as well as a section of the cloth. The Austrian authorities intervened and Barezzi's work was suspended. The English painter William Brockedon wrote from Milan on 24 August 1824: 'When I was here in 1821 a wretched quack in art had undertaken to restore this celebrated work. After having daubed over the left hand of Christ (his own ought to have shrunk at the attempt), and repainted part of the table and things upon it, he had so evidently betrayed his presumption and his ignorance, that public spirit enough was found, even in Milan, to appeal to the authorities, and stop his sacrilegious proceedings, which would have gone far with the next generation in blasting the reputation of Leonardo da Vinci'. (*Journals of Excursions in the Alps . . .*, London, 1833.)

After this disaster no further restorations were attempted for thirty years, though re-touching still went on apparently. At any rate William Boxall, later to become director of the National Gallery in London, wrote to his sister from Milan on 14 September 1845 that 'The picture is fast perishing, and the Head of Christ is much changed since I was here before when I made the sketch of it. It has also suffered from retouching since that time . . . the original is now little more than a shadow and I fear a few years more will wear it quite away.' (J. H. Liversidge: 'John Ruskin and William Boxall: unpublished correspondence' in *Apollo*, January 1967, p. 39).

By this date the painting seems to have been generally regarded as little more than a pathetic ruin. Kugler remarked, in the second edition of his *Handbook* (1847) that now 'when the ruins of the picture only exist, a custode has been appointed, and a scaffolding erected to admit of closer examination – not of Leonardo's work, for almost all trace of it has disappeared, but of its sad vicissitudes

and of the outrages which have been committed upon it.' In 1851, however, the President of the Accademia in Milan invited the chemist Kramer to study and report on the physical condition and composition of the painting and shortly afterwards (in September 1852) Barezzi once again applied to the Austrian authorities for permission to renew his experiments on *The Last Supper*, though these were no longer to be directed towards 'detaching' the painting from the wall but only towards re-laying with some strong glue the fragments of paint which were flaking off. Once again Barezzi's request was supported by the Accademia and in due course he was authorized to proceed, after a successful trial conducted before and examined by two Viennese scientists, Bohn and Engarth. Barezzi completed his restoration in 1855. It was later described by Adolfo Venturi as having been calamitous and it certainly did nothing to arrest the progress of deterioration and decay, as was reported only five years later by Mongeri who described the appearance of some alarming symptoms in St Philip's arm, the head of St Jude and the tunic of St Matthew.

In 1870 the glass-painter and fresco-restorer Guglielmo Botti, later Director of the Accademia in Venice, reported most unfavourably on the painting's condition and this was followed by a similar report from Pavesi by whom the 'intonaco' was chemically examined. But although Botti had put forward a proposal for detaching the painting from the wall, nothing appears to have been done except for improving the ventilation of the refectory. In fact, effective restoration did not begin until after 1900.

In 1891 Luca Beltrami became Superintendent of Monuments in Lombardy and in 1896 he had the original windows of the refectory re-opened in order to restore the original lighting conditions. At about the same time he set up a scientific commission, headed by Professors Carneluti, Gebba and Murani, to study and report on the structural, atmospheric and other physical conditions of the refectory and to make a chemical analysis of the paint surface and its support. Finally, in 1904, after a large scale photographic survey

had been made of all the heads and many other areas of the paint surface, L. Cavenaghi carried out two trial campaigns of 'consolidation'. These were judged successful and Cavenaghi was authorized to carry out a complete restoration, which he finished in 1908. His subsequent report on the condition and restoration of *The Last Supper* revealed that the painting had been executed in *tempera forte* on a complex prepared ground of two layers above the wall itself. (The second of these two layers, being predominantly of gesso, was not resistant to damp.) It also revealed that numerous traces of previous restorations remained but were confined for the most part to the background and the clothes of the Apostles, not to the heads or hands, with the exception of St Philip and the top of the table. Before beginning to restore the painting, Cavenaghi strengthened and consolidated the surface 'with a gum mastic diluted in suitable substances on which the hygrometric conditions would have the least possible effect'. But despite Cavenaghi's careful work and despite the various measures subsequently taken to reduce humidity and maintain an even temperature in the refectory, mould again appeared on the paint surface in 1911, and in 1921, according to E. Möller who was able to examine the paint surface closely from scaffolding, a considerable amount of paint had flaked off since 1908 when he had previously examined it at close range. Möller thought that very little indeed of the original paint surface was visible in 1921. In 1924 another restoration campaign began and was partially completed (by O. Silvestri) but by 1930 traces of mould and other indications of corrosion caused by the decay of earlier restorations were observed and yet another restoration campaign was proposed. It was not, however, carried out until after the Second World War, during which, from 1943 to 1946, the refectory was without a roof and open to the elements. *The Last Supper* survived behind a protective layer of sand-bags. After the war Mauro Pelliciolli carried out a thorough restoration which resulted in the recovery of a considerable amount of the original paint surface. (Cf. note 18.)

Appendix 4:
Copies of Leonardo's Last Supper

Leonardo's *Last Supper* has been copied almost continuously from the time it was painted until today [60], in media ranging from fresco and oil paint to tapestry, mosaic, stained glass and sculpture, and by artists as different as Rubens and Dominic Zappia, whose

60. The refectory *c.* 1900

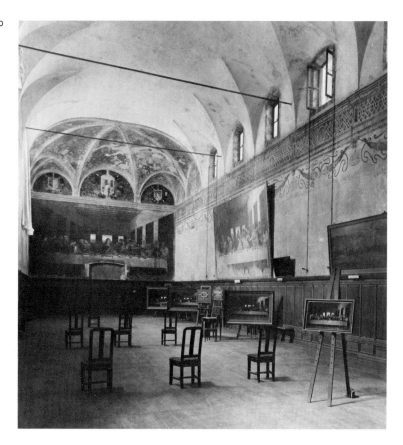

life-size sculptural group in basswood was made in 1962 and is now in the Protestant Chapel at John F. Kennedy Airport, New York [61] – not to mention the full-scale reproduction in stained glass at the Forest Lawn Cemetery at Los Angeles, the famous Whispering Glades of Evelyn Waugh's *The Loved One*. Engravings and other reproductions, frequently made from copies and not from the original – as we have already seen Goethe proposed to have an engraving made from a copy he saw in Rome – began equally early with the contemporary copper engraving ascribed to the Master of the Sforza Book of Hours [65]. (See A. M. Hind: *Early Italian Engraving*, London 1900, Part II, vol II, pp. 88–9.) And of course prints and reproductions by various processes have continued ever since.

61 (*opposite*). *The Last Supper*, 1962. D. Zappia

62. The Beggar's Banquet scene from Luis Buñuel's film *Viridiana*, 1961

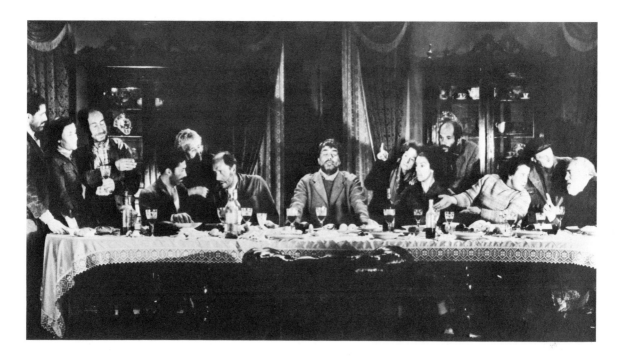

The interest of these innumerable copies lies in their value as records of *The Last Supper* at various stages of its physical deterioration and also, of course, as testimony of its continuous influence and fame – though perhaps such travesties as that of the beggars' banquet sequence in Buñuel's film *Viridiana* of 1961 provide the most convincing evidence of the latter [62]. It would, I think, be true to say that no other work of art could be used in such a way by a film-maker with any chance of it being recognized and understood by his public – except the *Mona Lisa*.

Several copies made during Leonardo's lifetime still survive but, as we have already mentioned, the best and most valuable copy is that made considerably later by André Dutertre and now in the Ashmolean Museum in Oxford [63].

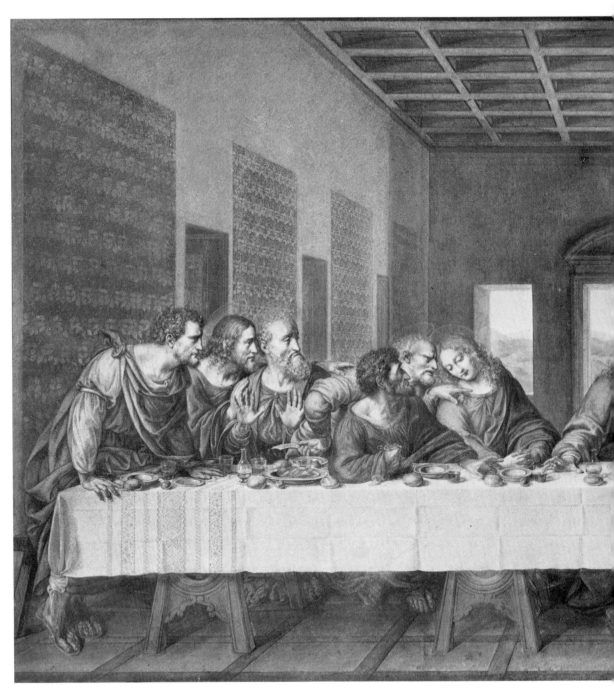

63. Copy of *The Last Supper*, 1789–94. André Dutertre

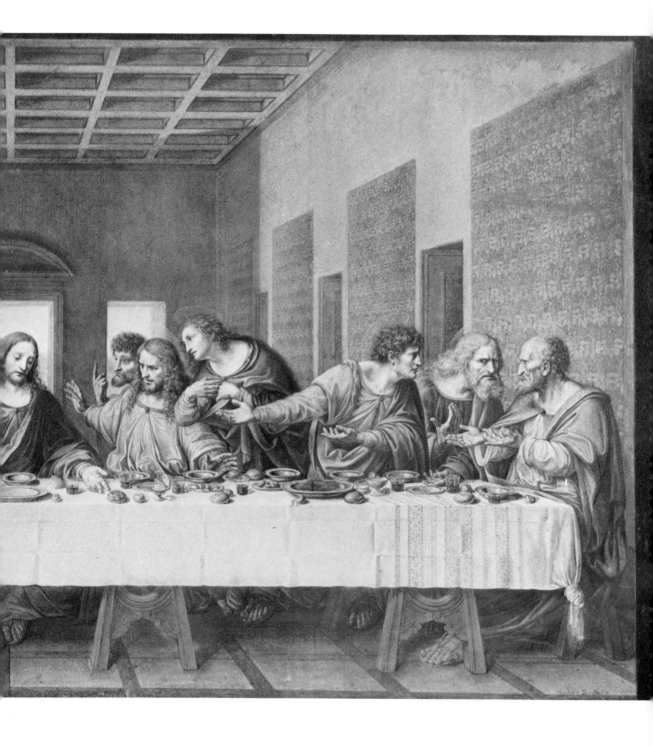

The earliest surviving copy appears to be that made by Antonio da Gessate in 1506 but it is in almost as poor condition as *The Last Supper* itself. (It was removed from the Ospedale Maggiore, Milan, in 1890 to S. Maria delle Grazie where it still remains.) Also dating from Leonardo's lifetime is the fresco of 1510-14 attributed to Andrea Solari, originally in the Hieronymite monastery at Castelazzo near Milan but now at S. Maria delle Grazie. (The famous drawings of the Apostles' heads, attributed to Solari and now in the museum at Weimar have been associated with this copy.) Also attributed to Solari is the copy now at Tongerlo in Belgium. This has been identified by Emil Möller (*Das Abendmahl des Leonardo da Vinci*, Baden Baden, 1952) with the copy mentioned in an inventory of 13 November 1540 of the castle of Gaillon belonging to Georges d'Amboise, archbishop of Rouen and prime minister to Louis XII. (See also R. H. Marijnissen, *Het da Vinci-Dock van de Abdij van Tongerlo*, Tongerlo, 1959.) Probably from about the same date – 1510-14 – is the copy in oil on canvas attributed to Marco d'Oggiono and, more recently, to Gianpietrino and now in the Royal Academy in London. It was recorded in the Certosa at Pavia in the seventeenth century and has been in England since 1815. It was engraved early in the nineteenth century by Giacomo Frey. Other copies attributed to Marco d'Oggiono are in the Louvre in Paris and the Hermitage in Leningrad.

Of about the same early date is a copy by Alessandro Araldi now in the Galleria Nazionale at Parma, though it is not recorded until 1530 when it was given to the Compagnia di SS. Cosma e Damiano in Parma. Slightly later, probably *c*. 1530, is the copy by Anselmi formerly in the now demolished S. Pietro Martire in Parma, and the interesting copy with variations at Ponte Capriasca near Lugano (dated 1547 and probably painted by Giovanni Pedrini). It includes an *Agony in the Garden* and a *Sacrifice of Isaac*. Among the later sixteenth-century copies should be mentioned that in fresco by Luini in S. Maria degli Angeli, Lugano, and those in the Capella di Revello near Saluzzo, in the Museo at Vercelli, in the Palazzo

Archivescovile at Milan, in the Chiesa dell'Assunta at Morbegno, in the cathedral at Turin, in the Pinacoteca at Teramo and in S. Germain l'Auxerrois in Paris. A drawing by Gaudenzio Ferrari is in the Brera, Milan. The copy by Vespino, commissioned by Cardinal Borromeo in 1612–13, is now in the Ambrosiana, Milan. Of the later copies that by Bossi was of course the best known, if only because of Goethe's essay, but it was destroyed in 1943. A version of Bossi's copy in mosaic by G. Raffaelli was made in 1816 for the Minoritenkirche in Vienna where it remains.

(For copies after Leonardo's *Last Supper* see G. Dehio: *Zu den Kopien nach Leonardos Abendmahl* Berlin, 1896; C. Horst in *Raccolta Vinciana*, Milan, 1930–34; Emil Möller: *Das Abendmahl des Leonardo da Vinci*, Baden Baden, 1952; Ludwig H. Heydenreich: 'André Dutertres Kopie des Abendmahls von Leonardo da Vinci' in *Münchener Jahrbuch der bildenden Kunst*, 1965, pp. 217ff. and A. Ottino della Chiesa: *L'opera completa di Leonardo pittore*, Milan, 1967.)

Notes

1. Carlo Cantù, 'Il convento e la chiesa delle Grazie e il Sant'Ufficio' in *Archivio Storico Lombardo* VI, 1879, pp. 223 ff.

2. After the completion of the choir the building of a splendid façade was also planned, and possibly the rebuilding of the nave although it had only been standing for ten years; in 1497 Lodovico was already demanding the plans for this. See Carlo Cantù, op. cit., loc. cit. and Arnaldo Bruschi, *L'Opera architettonica del Bramante*, Turin, 1969, p. 751.

3. On fol. 64 of Leonardo's notebook H (Paris, Bibliothèque Nationale) there is an entry: 'Quante braccie è alto il pian della mura. Quant'è larga la sala. Quant'è larga la ghirlanda. A di 29 de gienaro 1494'. (See L. Beltrami; *Documenti e memorie riguardanti la vita e le opere di Leonardo da Vinci*, Milan, 1919, doc. 61.) These questions as to the dimensions of a room have been connected by many scholars – with good reason in my view – with the commission for *The Last Supper*. As 'ghirlanda' can mean 'cornice' as well as 'garland', the word could refer to the painted moulding which originally ran round the whole refectory (see illustration 60). After the destruction of the room in 1944 only a fragment of this is preserved today, on the left-hand side wall.

4. In a list of instructions which Lodovico Sforza sent to his court marshal, Marchesino Stanga, under the date 29 June 1497 (see L. Beltrami, op. cit., doc. 76) is the passage: 'Item de' solicitare Leonardo Fior. no perchè finisca l'opera del Refettorio delle Gratie principiata, per attendere poi ad altra Fazada d'esso Refettorio et se faciamo con lui li capituli sottoscripti de mane sua che lo obligiano ad finirlo in quello tempo se convenera con lui . . .' The second part of the sentence suggests that Lodovico was considering stripping Montorfano's fresco of the Crucifixion off the opposite wall, although it had only been completed in 1494, and having it replaced by a painting by Leonardo, possibly another Crucifixion. (See W. von Seidlitz, *Leonardo da Vinci*, Berlin, 1909, p. 469; Aldo de Rinaldis, *Storia dell'opera pittorica di Leonardo*, Bologna, 1926, p. 14; and Angela Ottino della Chiesa, *Leonardo Pittore*, Milan, 1967, p. 99.) In the same year 1497 a bigger payment was recorded:

'per lavori facti in lo refectorio dove depinge Leonardo li apostoli'. (L. Beltrami, op. cit., doc. 77). Bandello's encounter with Leonardo occurred at the same period; it can be dated to 1497 by the documented simultaneous presence in the monastery of the Cardinal von Gurk. (L. Beltrami: op. cit., doc. 79; and W. von Seidlitz: op. cit., p. 153).

5. Matteo Bandello, *Le Novelle*, Bari, 1910, vol. II, p. 283. Translation by K. Clark, *Leonardo da Vinci*, Cambridge, 1939, pp. 92-3.

6. Leonardo was said to have searched for a long time in Borghetto, the slums of Milan, for a model for the head of Judas (Giambattista Giraldi, *Discorsi intorno al comporre dei romanzi . . .*, Venice, 1554, p. 194). Vasari also describes Leonardo's concern to work out and clarify the contrast between Christ and Judas as a dominant theme of the composition, and says that he left the head of Christ unfinished 'non pensando poter il dare quella divinità celeste che al'imagine di Christo si richiede' (feeling unable to represent the celestial beauty which the portrayal of Christ demanded). And Lomazzo (*Trattato* I, 80) reports that the painter Bernardo Zenale, when asked for advice by Leonardo, encouraged him not to finish it.

7. Antonio de Beatis, *Die Reise des Kardinals Luigi d'Aragona*, ed. Ludwig Pastor, Freiburg, 1905, p. 176.

8. G. B. Armenini, *De' veri precetti della pittura*, Ravenna, 1587 p. 172.

9. G. Vasari, *Le Vite . . .*, ed. Milanesi, Florence, 1880, vol. VI, p. 491.

10. The story of the decay and successive restorations of the picture is well summarised in W. von Seidlitz, op. cit., p. 155 and p. 470. See also L. Beltrami, *Le Vicende del Cenacolo dal 1495 al 1908*, Milan, 1909: Emil Möller, *Das Abendmahl des Leonardo da Vinci*, Baden Baden, 1952, p. 75 ff.; Angela Ottino della Chiesa, op. cit., pp. 96 ff., and our Appendix 2.

11. Roger de Piles, *Abrégé de la vie des peintres*, Paris, 1715, p. 161 ff.

12. *Lectures on Painting by the Royal Academicians. Barry, Opie and Fuseli*, ed. Ralph N. Wornum, London, 1848, pp. 128-9. Another version of the story was quoted by Allan Cunningham, *The Lives of the Most Eminent British Painters*, 1833 (ed. Mrs C. Heaton, London 1879, vol. i, pp. 384-9). For Giuseppe Mazza whom Barry calls Pietro Mazzi, see Emilio Motta in *Raccolta Vinciana* III, Milan, 1906-7.

13. K. T. Parker in *Ashmolean Museum, Report of the Visitors*, Oxford, 1958, p. 65 f.; L. H. Heydenreich, 'André Dutertres Kopie des Abendmahls von Leonardo da Vinci' in *Münchner Jahrbuch der bildenden Kunst* N.F. XVI, 1965, p. 217 f. Executed between 1789 and 1794, Dutertre's copy of *The Last Supper* is of particular significance in that it is the only

one which reflects the state of preservation of the picture immediately before it suffered fresh and serious damage during the military occupation of the monastery between 1796 and 1801. The original intention was that Raphael Morghen should make his engraving of *The Last Supper* after Dutertre's copy, and it was a great misfortune, in my opinion, that the political disturbances of the following years should have prevented this. Dutertre's reconstruction surpasses all other copies in that it has the exactness of an inventory [63]. This extends right down to the smallest details: the ornamental design in the tapestries, the pattern of the table cloth, the number and arrangement of the dishes of food and cutlery on the table, and especially the floor area – and square slabs of the pavement, the trestles supporting the table and, last but not least, the shape and position of the feet, a not unimportant part of the composition as a whole and nowhere rendered better or with greater exactitude than here.

Two details acquire some importance in connection with the problem of reconstructing *The Last Supper*. One is the fact that Dutertre's, in contrast to almost all older copies, does *not* let show the so-called 'left hand of Thomas' as part of Leonardo's final version of the picture. On the contrary, he gives most carefully the alteration as we see it now in the painting: a small plate with fruit on it and beside it a roll of bread have taken the place of a second hand beside the hand of James. Dutertre had thus consciously ignored this *pentimento* of Leonardo's – which had evidently become visible again in the course of the process of decay – and given preference instead (and certainly rightly, in my view) to the final version as adopted by Leonardo himself. On this see L. H. Heydenreich, op. cit., p. 228, note 37.

The second point concerns Peter's knife. While many copies show the knife in its sheath, here too Dutertre follows the painting as we see it today and shows a bare knife. This is an incomparably more effective motif, which in my view is also to be understood as an allusion to Peter's violent reaction when Christ was taken prisoner.

14. On the studies by Appiani and Matteini and the Strasbourg and Weimar series of Apostles' heads, see E. Möller, op. cit., p. 99 and W. von Seidlitz, op. cit., p. 169: on the engravings by Morghen and Frey see E. Möller, op. cit., p. 168. In the latter book there is a reproduction (plate no. 114) of Giuseppe Bossi's copy which was lost in the last war. The reproduction is valuable since the photographic negative was also destroyed during the war together with the rest of the contents of the Castello Sforzesco photographic library in Milan.

15. G. Bossi, *Del Cenacolo di Leonardo*, Milan, 1810, p. 200.

16. Gabriele d'Annunzio, *Tutte le opere, Versi d'Amore e di Gloria* II, Verona, 1952, p. 483.

17. Gino Chierici, 'Il Refettorio delle Grazie' in *Proporzioni* III, 1950.

18. The best account is to be found in Fernanda Wittgens, 'Restauro del Cenacolo' in *Leonardo: Saggi e ricerche*, Rome, 1954, p. 1 ff.

19. There is however one earlier, possibly archetypal example – the fresco of the Last Supper in the refectory of S. Paulo fuori le Mura in Rome, painted during the Papacy of Gregory VII (1073–85), but of which only a few fragments survive, see J. Wilpert, *Die römischen Mosaiken und Wandmalereien des Kirchlichen Bauten des IV bis XIII Jahrhunderts*, Freiburg, 1916, text II, 3, p. 847; pl. IV, 233.

20. See Artur Rosenauer, 'Zum Stil der frühen Werke Domenico Ghirlandajos' in *Wiener Jahrbuch für Kunstgeschichte*, XXII, 1969, pp. 59 ff., especially pp. 71 ff. See also L. Vertova, *I Cenacoli Fiorentini*, Turin, 1965, p. 41 and plates 1, XII and XIV. Leonardo may have known, before his move to Milan in 1480, many other depictions of the Last Supper in Florence, for example, Stefano di Antonio di Vanni's picture in the refectory of the Ospedale di S.Matteo painted in 1465-6 (see L. Vertova, op. cit., plate X) and the fresco from the same studio in the presbytery of Sant'Andrea at Cercina, near Florence (see L. Vertova, op. cit., fig. 18); but these were certainly not works that provided any inspiration. The works with which Leonardo would have been more or less familiar in Trecento panel painting can be deduced from the long catalogue of paintings of the Last Supper which R. Offner attached to his discussion of the Last Supper predella by the 'Master of the Fabriano Altarpiece' in Lord Bearsted's collection, see R. Offner: *Corpus of Florentine Paintings*, Section III, vol. VIII, New York, 1958, pp. 170 ff. But fundamentally the theme was still far from Leonardo's thoughts in his Florentine years and he had no reason to go into it in any detail at that time.

21. Thomas Brachert, 'A Musical Canon of Proportion in Leonardo da Vinci's *Last Supper*' in *Art Bulletin*, vol. LIII, no. 4, December 1971, pp. 461-7. Although Brachert's argumentation is not always impeccable – for instance, the cavalier treatment of the numerals inscribed on the Windsor drawing 12542 and the incorrect dating of Gafurio's publications – his main thesis is persuasive. His scheme of proportions makes it credible that Leonardo, in his space construction, had the congruence of perspective and musical proportions in mind. In his notes Leonardo compares them more than once. On the identity of harmonic proportions

in architecture and music, however, he never wrote explicitly although this notion had been familiar in art theory since Alberti (see the lucid exposition of this theory in R. Wittkower, *Architectural Principles in the Age of Humanism*, London, 1952, Part II 'The Problem of Harmonic Proportions in Architecture', pp. 89 ff., and see also the expanded edition *Grundlagen der Architektur im Zeitalter des Humanismus*, Munich, 1969, pp. 83 ff.

22. The best survey of this extensive and uncommonly varied material – a central theme in both the Eastern and Western Churches – is provided by H. Aurenhammer in his *Lexikon der christlichen Ikonographie*, Vienna, 1967, vol. I, pp. 11–15, where the older literature is also listed. Valuable for their rich illustration are: H. Detzel, *Christliche Ikonographie*, Freiburg in Breisgau, 1933, and G. Schiller, *Ikonographie der christlichen Kunst*, Gütersloh, 1966. See also K. Künstle, *Ikonographie der christlichen Kunst*, Freiburg, 1926–8, vol. I, pp. 413 ff.

23. P. Toesca, *La pittura e la miniatura nella Lombardia*, Turin, 1966, vol. I, p. 114 and fig. 187.

24. 'The Apostles' Communion' came to form a special type separate from the Last Supper theme, e.g. Justus van Ghent's picture at Urbino. A Last Supper in the proper sense of the phrase was painted by Fra Angelico only in the Passion cycle here illustrated [27].

25. Ms. South Kensington Museum II, fol. 62 verso/63 recto, printed in J. P. Richter, *The Literary Works of Leonardo da Vinci, compiled and edited from the original manuscripts*, London, 1883, vol. I, nos 665–6.

26. The drawing presents a number of problems. The execution is weak. The apparent pathos of the gestures lacks meaning and force; the lyrical motif of John lying on the breast of Our Lord is spoilt by exaggeration. The individual figures give for the most part an impression of plumpness; the hands are even clumsy. Nevertheless, it is an important fact that the Apostle second from the end on the right (Simon) was the only one to be incorporated almost unaltered in the painting (A. von Scheltema, *Über die Entwicklung der Abendmahlsdarstellung*, Leipzig, 1912, p. 61). Philip, however – second from the right in the lower sketch – also shows a resemblance, though not a close one, to James the Greater, the middle figure in the left-hand outer group in the painting. (In my view the Philip in the painting was originally rendered with one arm reaching down to the table, but in order to avoid an accumulation of hands in a narrow space Leonardo appears to have changed his mind and shown him with hands crossed on his breast.) All these considerations

suggest that the drawing may, after all, have been closely connected with Leonardo. Since the names written in above the Apostles to identify them are also almost certainly authentic (though A. M. Brizio considers them just as spurious as the drawing) this would seem to prove that Leonardo did make use of the drawing. In my view it could well be a studio copy of a preliminary design, in which even the left-hand shading has been reproduced. Discussion of the drawing has recently been revived, though without producing any absolutely convincing arguments on either side. See A. M. Brizio, 'Lo studio degli Apostoli della Cena dell'Accademia di Venezia' in *Raccolta Vinciana* XVIII, 1959, pp. 45 ff.; Carlo Pedretti, *Leonardo da Vinci inedito. Tre Saggi*. Florence, 1968, pp. 59-60; Luisa Cogliati Avane, *I disegni di Leonardo e della sua scuola a Venezia*, Venice, 1966, pp. 30 ff.

27. The studies at Venice and Windsor show this striving unmistakably. The use of the very old 'dialogue motif' has appeared since time immemorial in the iconography of the Apostles. In the Last Supper it is made use of for the first time, to the best of my knowledge, by Ghirlandaio. We find it again even more clearly in Cosimo Rosselli's *Institution of*

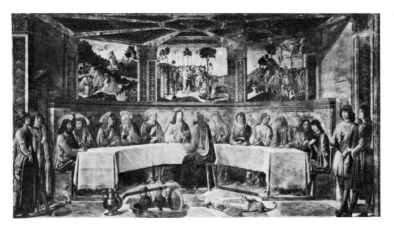

64. *The Institution of the Eucharist,* 1481-2. Cosimo Rosselli

the Eucharist in the Sistine Chapel, painted in 1481-2 [64]; and about the same time Andrea Sansovino (1483) also arranged his beautiful predella group on the Corbinelli altar in S. Spirito in the same way [32]. But the group of three is, in my view, not prefigured anywhere: it is Leonardo's most individual idea.

28. This text appears as an inscription on the contemporary copper engraving of *The Last Supper* [65] which Hind ascribes to the Master of

65. Engraving after *The Last Supper*. Attributed to the Master of the Sforza Book of Hours

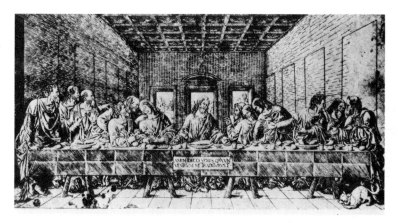

the Sforza Book of Hours (A. M. Hind, *Early Italian Engraving*, London, 1948, part II, vol. V, pp. 88-9). This print, or a copy of it, may have been the model for Rembrandt's version, see note 36 below, as Hind rightly deduces from the adoption of the little dog, which does not appear elsewhere.

29. In the iconographical tradition of the East and West throughout the centuries it is always just the two favourite disciples Peter and John and the guilty Judas who stand out or are made recognizable in various ways.

On the other hand, sometimes all the Apostles are identified by the addition of their names, for example by Castagno [11], though without giving them any distinguishing characteristics. It was this individual characterization at which Leonardo aimed - to be achieved through an intensive study of the scriptural texts.

My identification of the Apostles is supported by the copy of the *Last Supper* at Ponte Capriasca near Lugano (dated 1547 and probably painted by Giovanni Pedrini) on which the names are given. Only James the Greater and James the Less are there confused in my opinion. See also E. Möller, *Das Abendmahl des Leonardo*, Baden Baden, 1952, pp. 56-7.

30. Dutertre's drawing, and also the painting at Tongerlo, reveal more clearly than any other copies, the important part played by the feet of the Apostles and of Christ and of their garments in so far as they are perceptible in the semi-darkness under the table. It is only when seen as a whole that the quiet composure of the figure of Christ is fully realized. In contrast to his still, firmly planted feet the restless positions of those of the Apostles form a sort of counterpart to the gestures of the hands above.

31. On this point see H. von Einem: *Das Abendmahl des Leonardo da Vinci*, Cologne and Opladen, 1961, pp. 62 ff.

32. In Dutertre's reconstruction this very carefully thought-out arrangement of the objects on the table is particularly clear. It is also to be seen in the Tongerlo copy.

33. The complexity of the painting has opened the door to a variety of interpretations. For example, Edgar Wind (*Listener*, 8 May 1952, pp. 747–8) drew attention to several possible layers of meaning in the painting, stressing 'one of the cardinal points in theological interpretation, that any event that is announced in the Bible can be interpreted in four ways – the literal, the moral, the mystical, and the anagogical. . . . It seems to me, if one looks at these four groups, each composed of three characters on either side of Christ, they really express by their gestures, very simply and eloquently, these four states: the anagogical, leading up to the acceptance of the bread and the wine in the group at the extreme right: the mystical in the ecstatic, excited reaction in the next group, also on the right of Christ; and literal, on the left side – the negative side, where the hand of Christ is cramped and semi-closed; the moral at the extreme left in the violence with which St Andrew and St Bartholomew react to the announcement.' And Wind goes on to suggest that each of the groups may also be identified with one of the four temperaments.

34. See Vasari's lively account, ed. Milanesi IV, p. 38.

35. See E. Panofsky, *The Life and Art of Albrecht Dürer*, Princeton, 1955, pp. 221–3.

36. See K. Clark, *Rembrandt and the Italian Renaissance*, London, 1966, pp. 53 ff.

37. For literary reasons quotations from the Gospels throughout the text are from the King James Bible.

List of Illustrations

Colour plate and title page: *The Last Supper*. By Leonardo da Vinci, 1494–8. Tempera 460 x 880 cm. Milan, S. Maria delle Grazie. (Photo: Soprintendenza.)

1. Detail of the *Pala Sforzesca*. Anonymous, *c.* 1495. Milan, Pinacoteca di Brera. (Photo: Alinari.)

2. Choir of S. Maria delle Grazie, Milan. By Bramante, 1492. (Photo: Paoletti.)

3. Plan and section of the refectory, S. Maria delle Grazie, Milan. Drawn by Giuseppe Chigiotti.

4. The refectory, S. Maria delle Grazie, Milan. (Photo: Soprintendenza.)

5. Copy of *The Last Supper*. By André Dutertre, 1789–94. Oxford, Ashmolean Museum. (Photo: Museum.)

6. Engraving after *The Last Supper*. By Raphael Morghen, 1800. Florence, Uffizi (Photo: Museum.)

7. The bombed refectory, 1943. *The Last Supper* is behind the sand-bags, bottom right. (Photo: Emmer.)

8. *The Last Supper*. By Leonardo da Vinci, 1494–8, after the 1954 restoration. (Photo: Soprintendenza.)

9. *The Last Supper and Other Scenes*. By Taddeo Gaddi, *c.* 1350. Fresco. Florence, S. Croce. (Photo: Alinari.)

10. Fragment of *The Last Supper*. By Andrea Orcagna's workshop, *c.* 1365. Fresco. Florence, S. Spirito. (Photo: Soprintendenza.)

11. *The Last Supper, Crucifixion, Entombment and Resurrection* (before the recent cleaning and restoration). By Andrea del Castagno, *c.* 1450. Fresco. Florence, S. Apollonio. (Photo: Alinari.)

12. *The Last Supper*. By Domenico Ghirlandaio, 1480. Fresco. Florence, Monastery of Ognissanti. (Photo: Soprintendenza.)

13. *The Last Supper*. By Domenico and Davide Ghirlandaio, *c.* 1470–79. Fresco. Passignano, Monastery. (Photo: Soprintendenza.)

14. Study for St. Peter. By Leonardo da Vinci, *c.* 1495. Pen and ink over metal-point on blue prepared surface, 14.5 x 11.3 cm. Vienna, Albertina. (Photo: Museum.)

15. Detail of 13.

16. Detail of 11.

17. Woodcut from Franchino Gafurio, *De Harmonia musicorum instrumentorum*, 1518. It was first printed in Gafurio's *Angelicum* of 1508. (Photo: John R. Freeman.)

18. *Agape*. Wall painting, late second century. Rome, catacomb of Priscilla. (Photo: Pont. Comm. di Arch. Sacra.)

19. *The Last Supper*. From the Codex Rossanensis, sixth century. Rossano. (Photo: Giraudon.)

20. *The Last Supper*. Mosaic, early sixth century. Ravenna, S. Apollinare Nuovo. (Photo: German Archaeological Institute, Rome.)

21. *The Last Supper*. Mosaic, *c.* 1250-1300. Florence, Baptistery. (Photo: Soprintendenza.)

22. *The Last Supper*. Sixth century. Milan, Biblioteca Ambrosiana, Ms. D.67. 73v. (Photo: Ambrosiana.)

23. *The Last Supper*. Marble, twelfth century. Volterra Cathedral, detail of pulpit. (Photo: Alinari.)

24. *The Last Supper*. By Giotto, *c.* 1303-13. Fresco, Padua, Scrovegni Chapel. (Photo: Anderson.)

25. *The Last Supper*. By Sassetta, 1423-6. Siena, Pinacoteca. (Photo: Alinari.)

26. *The Last Supper*. Lombard School, late fourteenth century. Viboldone, Abbazia di S. Pietro. (Photo: Soprintendenza.)

27. *The Last Supper*. By Fra Angelico, *c.* 1448-61. Florence, Museo di San Marco. (Photo: Brogi.)

28. Study for *The Last Supper with Architectural Figures and Calculations*. By Leonardo da Vinci, *c.* 1495-7. Windsor, Royal Library, no. 12542. Pen and ink, 26 x 21 cm. (Photo: Royal Library, reproduced by gracious permission of H.M. the Queen.)

29. Study for *The Last Supper*. After Leonardo da Vinci, *c.* 1495-7. Red chalk, 26 x 39 cm. Venice, Academy. (Photo: Anderson.)

30. Detail of 28.

31. Detail of 28.

32. *The Last Supper*. By Andrea Sansovino, *c.* 1485-90. Marble. Florence, S. Spirito. Detail of the Corbinelli altar. (Photo: G. Laurati.)

33. Studies for *The Adoration of the Magi*. By Leonardo da Vinci, *c.* 1481. Pen, ink and metal-point, 27.8 x 20.8 cm. Paris, Louvre. (Photo: Museum.)

34. *The Last Supper*. (Photo: Soprintendenza.)

35. Detail of 34. (Photo: Soprintendenza.)

36. Study for the head of Judas. By Leonardo da Vinci, 1494–7. Red chalk, 18 x 15 cm. Windsor, Royal Library no. 12547. (Photo: Royal Library, reproduced by gracious permission of H.M. the Queen.)

37. Study for the hands of St John. By Leonardo da Vinci, 1494–7. Black chalk, 11.7 x 15.2 cm. Windsor, Royal Library no. 12543. (Photo: Royal Library, reproduced by gracious permission of H.M. the Queen.)

38. Study for the arm of St Peter. By Leonardo da Vinci, 1494–7. Black chalk, heightened with white, 16.6 x 15.5 cm. Windsor, Royal Library no. 12546. (Photo: Royal Library, reproduced by gracious permission of H.M. the Queen.)

39. Detail of *The Last Supper*. (Photo: Soprintendenza.)

40. Study for St Bartholomew. By Leonardo da Vinci, 1494–7. Red chalk, 19.3 x 14.8 cm. Windsor, Royal Library no. 12548. (Photo: Royal Library, reproduced by gracious permission of H.M. the Queen.)

41. Detail of *The Last Supper*. (Photo: Soprintendenza.)

42. Study for St James the Less. By Leonardo da Vinci, 1494–7. Red chalk and pen and ink, 25.2 x 17.2 cm. Windsor, Royal Library no. 12552. (Photo: Royal Library, reproduced by gracious permission of H.M. the Queen.)

43. Study for St. Philip. By Leonardo da Vinci, 1494–7. Black chalk, 19 x 15 cm. Windsor, Royal Library no. 12551. (Photo: Royal Library, reproduced by gracious permission of H.M. the Queen.)

44. Detail of *The Last Supper*. (Photo: Soprintendenza.)

45. Detail of *The Last Supper*. (Photo: Soprintendenza.)

46. Detail from a copy of *The Last Supper*. Attributed to Marco d'Oggiono, *c.* 1510–14. London, Royal Academy. (Photo: Royal Academy.)

47. *Head of Christ*. By a follower of Leonardo. Milan, Pinacoteca di Brera. (Photo: Soprintendenza.)

48. *Head of Christ*. By a follower of Leonardo. Strasbourg, Musée de la Ville. (Photo: Museum.)

49. *The Adoration of the Magi*. By Leonardo da Vinci, *c.* 1481. Florence, Uffizi. (Photo: Alinari.)

50. Detail of 49. (Photo: Soprintendenza.)

51. Detail of 49. (Photo: Soprintendenza.)

52. Detail of 49. (Photo: Alinari.)

53. Detail of *The Last Supper*. (Photo: Soprintendenza.)

54. Detail of 5.

55. Detail of *The Last Supper*. (Photo: Soprintendenza.)

56. *The Last Supper*. By Andrea del Sarto, *c.* 1520–25. Florence, S. Salvi. (Photo: Brogi.)

57. *The Last Supper*. By Titian, 1564. The Escorial. (Photo: Anderson.)

58. *The Last Supper*. By Dürer, 1523. (Photo: The Warburg Institute.)

59. *The Last Supper*. By Rembrandt, *c.* 1635. New York, the Robert Lehman Collection. (Reproduced by courtesy of the Robert Lehman Collection, New York.)

60. The refectory, S. Maria delle Grazie, *c.* 1900. (Photo: Brogi.)

61. *The Last Supper*. By Dominic Zappia, 1962. Basswood. New York, the Protestant Chapel, John F. Kennedy International Airport. (Reproduced by courtesy of the Protestant Chapel, John F. Kennedy International Airport, New York.)

62. The Beggars' Banquet scene from Luis Buñuel's film *Viridiana*, 1961. (Photo by courtesy of the National Film Institute, London.)

63. Copy of *The Last Supper*. By André Dutertre. (See illustration 5.)

64. *The Institution of the Eucharist*. By Cosimo Rosselli, 1481–2. Rome, Vatican, Sistine Chapel. (Photo: Biblioteca Hertziana, Rome.)

65. Engraving after *The Last Supper*. Attributed to the Master of the Sforza Books of Hours.

Bibliography

More has been written about Leonardo's *Last Supper* than about any other work of art, with the possible exception of the Ghent Altarpiece, so the following bibliography is necessarily summary.

Monographs begin with Domenico Pino, *Storia genuina del Cenacolo insigne dipinto del Leonardo da Vinci nel refettorio di S. Maria delle Grazie di Milano*, Milan, 1796, and continue with Giuseppe Bossi, *Del Cenacolo di Leonardo. Libri Quattro . . .* , Milan, 1810, which collects numerous early descriptions; A. Guillon: *Le Cénacle de Léonard de Vinci*, Milan, 1811; [Giuseppe Bossi], *Postillo alle Osservazione sul volume intitolato Del Cenacolo di Leonardo da Vinci. Libri Quattro . . .* , Milan, 1812; Hermann Dalton, *Lionardo da Vinci und seine Darstellung des heiligen Abendmahls*, St Petersburg, 1874; E. Frantz, *Das heiliges Abendmahl des Leonardo*, Freiburg, 1885; O. Hoerth, *Das Abendmahl des Leonardo*, Leipzig, 1907; C. Ricci, *Il Cenacolo di Leonardo da Vinci*, Rome, 1907; L. Beltrami, *Il Cenacolo di Leonardo 1495–1908*, Milan, 1908; A. Melani, *Il Cenacolo di Leonardo*, Pistoia, 1908; E. Schaeffer, *Leonardo da Vinci. Das Abendmahl*, Berlin, 1914; G. Galbiati, *Il Cenacolo di Leonardo da Vinci del pittore Giuseppe Bossi nei giudizi d'illustri contemporanei*, Milan-Rome, 1919; M. Salmi, *Il Cenacolo*, Milan n.d. [1927]; A. Pica, *L'opera di Leonardo al convento delle Grazie in Milano*, Rome, 1939; S. Bottari, *Il Cenacolo di Leonardo*, Bergamo, 1948; E. Möller, *Das Abendmahl des Leonardo da Vinci*, Baden Baden, 1952; Paolo d'Ancona, *Das Abendmahl der Leonardo da Vinci*. Milan, 1955; L. H. Heydenreich, *Leonardo da Vinci. Das Abendmahl*, Stuttgart, 1958; H. von Einem, *Das Abendmahl des Leonardo da Vinci*, Cologne and Opladen, 1961; F. Wittgens, *Il Cenacolo di Leonardo da Vinci*, Milan, 1964; F. Mazzini, *Il Cenacolo di Leonardo e la Chiesa delle Grazie*, Milan, 1966; P. Angelo M. Caccin, *S.Maria delle Grazie e il Cenacolo Vinciano*, Milan, 1967.

Many descriptions and analyses of *The Last Supper* have been published of which the following may be mentioned here: A. von Scheltema, *Über die Entwicklung der Abendmahlsdarstellung*, Leipzig, 1912; C. Horst, 'L'Ultima Cena di Leonardo nel riflesso delle copie e delle imitazione' in

Raccolta Vinciana XIV, 1930-34, pp. 118-200; Edgar Wind, 'The Last Supper' in the *Listener*, 8 May, 1952; A. Bovi, 'La visione del colore e della luce nella Cena' in *Raccolta Vinciana* XVII, 1954, pp. 315 ff.; V. Mariani: 'Della "Composizione" nel Cenacolo di Leonardo' in *Arte Lombarda* II, 1956, pp. 65 ff.; G. Castelfranco in *Storio di Milano* VIII 'Fra Francia e Spagna', Milan, 1957, pp. 514 ff.

General accounts of *The Last Supper* may be found in J. Burckhardt, *Cicerone*, 1855; G. Séailles: *Leonardo da Vinci*, Paris, 1892; H. Wölfflin, *Classic Art*, Munich, 1898, London, 1952; W. von Seidlitz, *Leonardo da Vinci*, Berlin, 1909; Vienna, 1935; A. de Rinaldis, *Storia dell'opera pittorica di Leonardo*, Bologna, 1926; K. Clark, *Leonardo da Vinci*, Cambridge, 1939; L. H. Heydenreich, *Leonardo da Vinci*, Berlin, 1943; Basle, 1954.

On the Milanese background there is F. Malaguzzi-Valeri, *La Corte di Lodovico il Moro*, Milan, 1915, vol. II.

On the drawings there are A. E. Popham, *The Drawings of Leonardo da Vinci*, London, 1946; K. Clark and C. Pedretti, *The Drawings of Leonardo da Vinci in the Collection of H.M. the Queen at Windsor Castle* (1935), revised edition, London, 1968; Luisa Cogliati Avane: *I disegni di Leonardo e della sua scuola a Venezia*, Venice, 1966.

On the colour there is J. Shearman: 'Leonardo's Colour and Chiaroscuro' in *Zeitschrift für Kunstgeschichte* XXV, 1962, pp. 13-47.

On iconography there are the classic articles by E. Dobbert in *Repertorium für Kunstwissenschaft* XIII (1890) 281 ff., 303 ff., 423 ff.; XIV (1891) 175 ff., 451 ff.; XV (1892) 357 ff., 506 ff.; XVIII (1895) 336 ff., and, for Byzantine iconography, G. Millet, *Recherches sur l'iconographie de l'Evangile aux XIVe XVe et XVIe siècles d'après les monuments de Mistra, de la Macédoine et du Mont Athos*, Paris, 1916. An excellent survey is contained in H. Aurenhammer, *Lexikon der christlichen Ikonographie*, Vienna, 1967, vol. I, pp. 11-15 including a useful list of the older literature of which the following may be mentioned here especially for their abundant illustrations - H. Detzel, *Christliche Ikonographie*, Freiburg in Breisgau, 1933; G. Schiller, *Ikonographie der christlichen Kunst*, Gütersloh, 1966; K. Künstle: *Ikonographie der christlichen Kunst*, Freiburg in Breisgau 1926-8, vol. 1, pp. 413 ff. and Luisa Vertova, *I Cenacoli Fiorentini*, Turin, 1965.

Special studies relating to Leonardo's *Last Supper* include Anon, *Le Vicende del Cenacolo di Leonardo da Vinci nel secolo XIX*, Milan, 1906 (relating mainly to cleaning and restoration); G. Dehio, *Zu den Kopien*

nach Leonardos Abendmahl, Berlin, 1896; Fernanda Wittgens in *Saggi e Ricerche*, Rome, 1953; T. Brachert, 'A Musical Canon of Proportion in Leonardo da Vinci's Last Supper' in *Art Bulletin* vol. LIII, no. 4, December 1971.

Index

Bold numbers refer to illustration numbers

Agape, 32, **18**
Andrea del Sarto, 66, 68–9, **56**
Fra Angelico, 38, **27**
d'Annunzio, Gabriele, 22
Anselmi, Michelangelo, 104
Antonio da Gessate, 104
Appiani, Andrea, 20, 22, 94, 109
Araldi, Alessandro, 104
Armenini, Giovanni Battista, 16

Bandello, Matteo, 15, 16, 108
Barozzi, Stefano, 22, 94–6
Barry, James, 18, 19
Bartoli, Francesco, 92
de Beatis, Antonio, 16
Bellotti, Michelangelo, 91, 92, 93
Beltrami, Luca, 96
Bianconi, Carlo, 93
Borromeo, Cardinal Federico, 91, 105
Bosca, Padre, 94
Bossi, Giuseppe, 20, 22, 105, 109
Botti, Guglielmo, 96
Boxall, William, 95
Bramante, Donato, 14, **2**
Brockedon, William, 95
Buñuel, Luis, 107, **62**

Cavenaghi, Luigi, 97
Castagno, Andrea del, 27, 30, 113, **11**
Castelazzo, Hieronymite monastery, 104

Duccio, 37
Dürer, Albrecht, 69, **58**
Dutertre, André, 20, 108–9, 113, **5**, **54**, **63**

Escorial, 69

Florence, Baptistery, **21**
 S. Andrea (Cercina), 110
 S. Apollonio, 27, **11**
 S. Croce, 27, **9**
 S. Marco, 29, 38, **27**
 S. Spirito, 27, 112, **10**, **32**
 S. Salvi, **56**
 Ognissanti, 29, **12**
 Ospedale di S. Matteo, 110
 Uffizi, 44, 57, 59, **49**, **50**, **51**, **52**
Frey, Giacomo, 20, 69, 104

Gaddi, Taddeo, 27, 29, **9**
Gafurio, Franchino, 31, 32, **17**
Galliani, Padre, 94
Gallieri, Paolo, 19
Georges d'Amboise, 104
Ghirlandaio, Davide, 29, 30, **13**
Ghirlandaio, Domenico, 27, 29, 30, **12**, **13**
Gianpietrino, 104
Giotto, 37, **24**
Goethe, 20, 85–90

Harmonic proportions, 31, 32, 110–11

Justus van Ghent, 111

Kugler, F., 95–6

La Condamine, Charles-Marie de, 92
Latuada, S., 92
Leningrad, the Hermitage, 104
Leonardo, *The Adoration of the Magi*, 57, **49**, **50**, **51**, **52**
 study for *The Adoration of the Magi*, 44, 46, **33**
 St Anne, Madonna and Child, 67
 Treatise on Painting, 65–6

Lodovico il Moro, Duke of Milan, 12, 14, 105, **1**
Lomazzo, Giov. Paolo, 92, 108
London, Royal Academy, 104, **46**
Los Angeles, Forest Lawn Cemetery, 100
Lugano, S. Maria degli Angeli, 104
Luini, Bernardino, 94, 104

Marco d'Oggiono, 104, **46**
Master of the Sforza Book of Hours, 112–13, **65**
Matteini, Teodoro, 20, 109
Mazza, Giuseppe, 19, 92–4, 108
Milan, Ambrosiana, 91, 105, **22**
 Brera, 105, **47**
 Ospedale Maggiore, 104
 Palazzo Archivescovile, 105
Möller, E., 97
Mongeri, 96
Morbegno, chiesa dell'Assunta, 105
Morghen, Raphael, 20, 69, 109, **6**

Napoleon, 20
New York, J. F. Kennedy Airport Protestant Chapel, **61**
 Robert Lehmann collection, **59**

Orcagna, Andrea, 27, **10**
Oxford, Ashmolean Museum, 20, **5, 54, 63**

Pacioli, Luca, 12
Padua, Scrovegni chapel, **24**
Paris, S. Germain l'Auxerrois, 105
 Louvre, 44, 104, **33**
Parma, Galleria Nazionale, 104
Passignano, Monastery, 29, **13**
Pavia, Certosa, 104
Pedrini, Giovanni, 104, 113
Pellicioli, Mauro, 23, 97
de Piles, Roger, 18
Ponte Capriasca, 104, 113
Porro, Padre Giuseppe Antonio, 20

Raffaelli, G., 105
Raimondi, Marc Antonio, 69

Raphael, 31, 69
Ravenna, S. Appollinare Nuovo, 20
Rembrandt, 69, 113, **59**
Richardson, Jonathan, 91–2
Rome, catacomb of Priscilla, 32, **18**
 S. Paolo fuori le Mura, 110
 Vatican, 32, 112, **64**
Rossano codex, **19**
Rosselli, Cosimo, 112, **64**
Rubens, 18

Saluzzo, capella di Revello, 104
Sansovino, Andrea, 44, 112, **32**
Sassetta, 37, **25**
Siena, Pinacoteca, **25**
Silvestri, O., 97
Solari, Andrea, 104
Stefano di Antonio di Vanni, 110
Strasbourg, Musée de la Ville, 109, **48**

Teramo, Pinacoteca, 105
Titian, 69, **57**
Tongerlo, 104, 113
Turin cathedral, 105

Vasari, Giorgio, 16, 18, 108
Venice, Accademia, 41, 44, **29**
Vercelli, Museo, 104
Vespino (Andrea Bianchi), 91, 105
Viboldone, Abbazia di S. Pietro, 38, **26**
Vienna, Albertina, 30, **14**
 Minoritenkirche, 105
Vimercato, Count Gaspare, 14
Volterra cathedral, **23**

Waugh, Evelyn, 100
Weimar, Schlossmuseum, 20, 104, 109
Windsor Castle, Royal Library, 30, 41–3, **28, 30, 31, 36, 37, 38, 40, 42, 43**

Zappia, Domenic, 99–100, **61**
Zenale, Bernardo, 108